CONTINUITY AND CHANGE
TWENTIETH CENTURY SCULPTURE
IN THE ASHMOLEAN MUSEUM

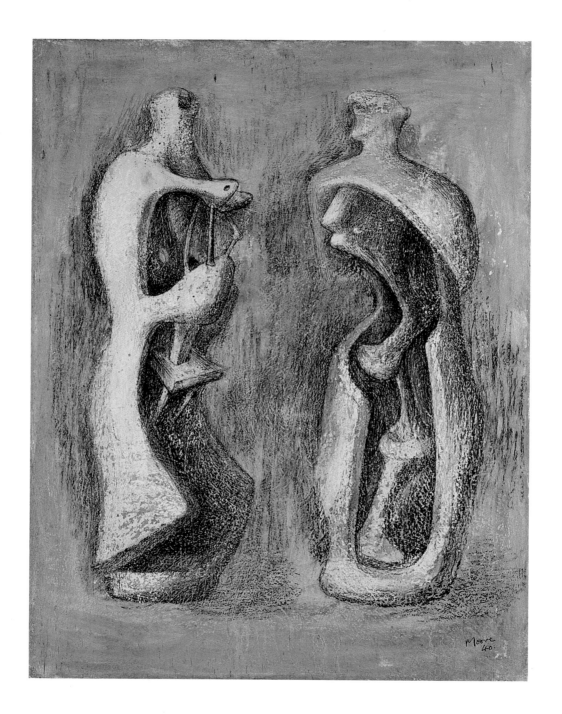

CONTINUITY AND CHANGE
TWENTIETH CENTURY SCULPTURE
IN THE ASHMOLEAN MUSEUM

Katharine Eustace

Ashmolean Museum Oxford

2001

Published with the aid of a generous grant from the
Henry Moore Foundation and the Elias Ashmole Group

Titles in the series include:
The Ashmolean Museum
Ruskin's Drawings
Drawings by Michelangelo and Raphael
Oxford and the Pre-Raphaelites
Miniatures
J.M.W. Turner
Samuel Palmer
Camille Pissarro and his family
Twentieth century Paintings
Indian Paintings from Oxford collections
Ancient Greek Pottery
Worcester Porcelain
Maiolica
Islamic Ceramics
Eighteenth-century French Porcelain
English Delftware
Glass of four Millennia

ISBN 185444 147 7 (papercased)
ISBN 1 85444 146 9 (paperback)

British Library Cataloguing in Publication Data
A catalogue record for this book is available from the
British Library

Designed and typeset in Bauer Bodoni by Tim Harvey
Printed and bound in Belgium
by Snoeck-Ducaju & Zoon, Ghent

Front cover illustration
Leon Underwood, *Elijah's Meat*, 1938 (PLATE 27)

Back cover illustration
Winifred Turner, *Reclining Woman and Child*, 1930s
(PLATE 4)

Frontispiece
Henry Moore, *Two Standing Figures*, 1940 (PLATE 22)

Pages 6–7
FIG. 16 Jacob Epstein, *The Trades Union Congress
Memorial*, 1958. Congress House, Great Russell Street,
London

CONTENTS

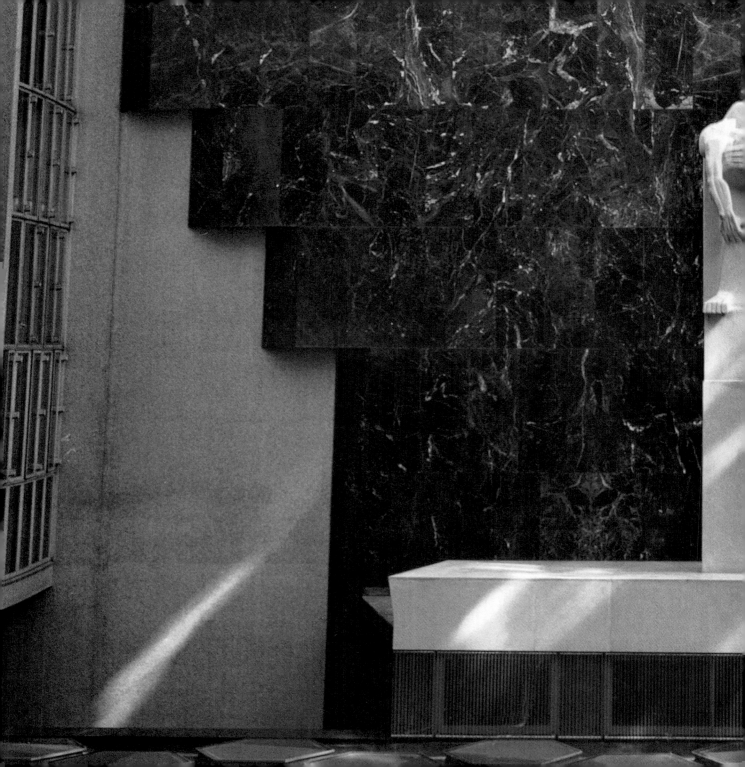

Acknowledgements

All works unless otherwise stated are in the collection of
the Ashmolean Museum and appear in the summary
catalogue at the end. The reader is referred, where
relevant, for further detail on individual works to
Nicholas Penny, *Catalogue of European Sculpture in the
Ashmolean Museum 1540 to the Present Day* (3 vols.,
Oxford, 1992). All works in that catalogue are referred to
here as NBP and accession number. Measurements are
given in millimetres in the order height × length × width.

Many people have been involved in the process of
displaying the sculpture collection and in the production
of this book, for the design of which I would like to
thank Tim Harvey. All the work had to be
photographed, a feat organised by Anna Taylor,
Photographic Archivist, who also dealt with innumerable
details; it was sensitively accomplished by David Gowers
and his team. Conservation work was overseen by Mark
Norman and Shulla Jacques, and thanks too to Katrina
Stokes, acting secretary in the Department of Western
Art.

I would also like to thank Ian Charlton, Sue Moss,
Alison Oldfield and Helen Cooper in the Publications
Department.

Katharine Eustace

FOREWORD

The occasion of the publication of this book is the opening of the Sands Gallery of Early Twentieth-Century European Painting and Sculpture, supported by the Heritage Lottery Fund. This is the first new display space for European paintings and sculpture in the Museum in fifty years. It has provided an exciting opportunity to make accessible for the first time many works which will come both as a pleasure and a surprise.

The Henry Moore Foundation and the Elias Ashmole Group, the Museum's Patrons, have made this publication possible. It accompanies the display of the Ashmolean's twentieth-century sculpture, most of which has rarely, if ever, been seen before. I am grateful to both for their continued support of the museum and its activities. Written by my colleague Katharine Eustace, this book provides an accessible account of the works on display, their individual histories, their place in the context of the Museum's collections as a whole and in the broader spectrum of European sculpture in the twentieth century.

A point that does emerge very clearly is how much this area of the Ashmolean's collections is indebted to the generosity of individual benefactors. Their public-spiritedness has, over the years, enriched the collections of this great museum. We can now do justice to their generosity and in so doing enhance the experience of our visitors. I would like particularly to record the generosity of Garth Underwood in his presentation of his father's work, and Stella Saludes and the late Beryl Bjelke and Valerie Hewett, the sisters of Christopher Hewett, in their gift of their brother's remarkable collection. The one group marks an important sense of continuity, the other that sense of change which will carry the Ashmolean Museum confidently into the twenty-first century.

DR CHRISTOPHER BROWN
Director

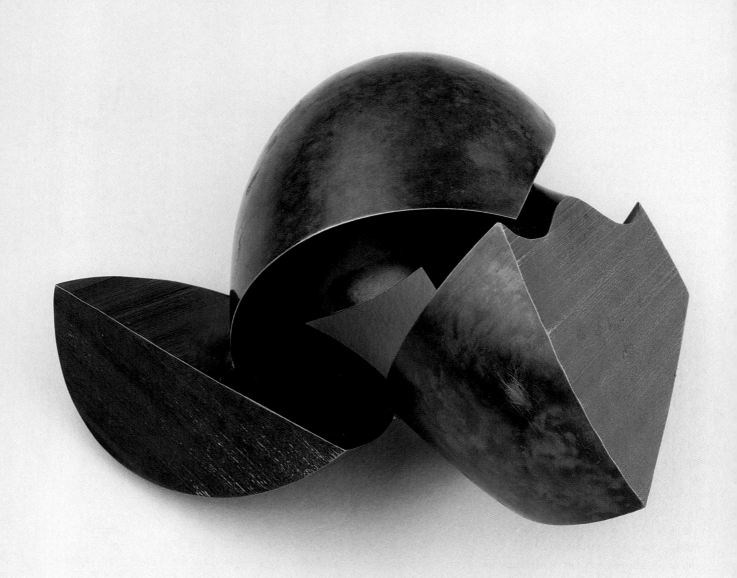

CONTINUITY AND CHANGE

THE ASHMOLEAN MUSEUM has from its earliest days been engaged in the business of collecting and displaying sculpture. Many of its most important gifts and bequests have been of sculpture and, significantly, they came in groups and in already formed collections: John Selden's *Lapidarium* given to the University in 1654, the Pomfret gift of the Arundel Marbles in 1755, the Chantrey Gift of 1842, C.D.E. Fortnum's collection of Renaissance bronzes in 1899, and the Brocklebank bronzes of 1926. The sculpture was in many cases immediately contemporary when it entered its various source collections. The Moretti figures *all antica* of 1614 (FIG. 1) were just as much a contemporary response to the classical tradition as was Henry Moore's *Fragment Figure* (PLATE 24). In other words, as Nicholas Penny has pointed out, in the mid to late nineteenth century 'modern art ... was as prominent [in the University Galleries] as were the casts after the antique and the drawings by Raphael and Michelangelo'(III, p.xxxv). Much of the work was by living artists, notably in the Brocklebank Bequest.

The Ashmolean collections are rooted in the classical tradition, and this is reflected in the gifts of sculpture accepted by the museum in the twentieth century. It is noteworthy that in the twentieth century not one piece of contemporary sculpture was purchased, which

FIG. 1a and b Egidio Moretti (active 1611–38), Roman figures *all antica*, 1614. Marble. Presented by the Dowager Countess of Pomfret, 1755. NBP 65 and 67.

is to say that the museum's collecting policy was therefore passive and haphazard. This must be a matter for regret, as it is in sculpture, in Britain in particular, that so much of the creative energy of the century found significant expression. How much more conscious are we, therefore, that the small but diverse and exciting group that this publication reveals has found a resting place in the Ashmolean, due to

the generosity of individuals. Only one or two of the pieces of sculpture illustrated here has ever been displayed in the permanent galleries, so the opportunity afforded by the new gallery of displaying twentieth-century sculpture for the first time, is a cause for celebration.

The group is not in any way fully representative of the twentieth century, failing almost entirely to reflect the great tensions and radical departures that characterised creative expression in the Western world. Nor in the matter of materials and facture does the work depart from the ancient traditions of modelling, carving and casting, the emphasis being overwhelmingly in favour of modelling and casting in bronze. Also, there is very little 'direct carving', itself one of the hallmarks of the modernist movement in Britain. The ready-made, the found-object, the raw material so characteristic of twentieth-century sculpture since Duchamp's *Bottlerack* of 1914, is certainly not in evidence.

The twentieth century's visual dilemma lay between the twin poles of figuration and abstraction, and there are threads running through the collection that address some of the problems of the mainstream. But if the collection cannot tell the whole story, it can at least provide pieces in the jigsaw. The purpose of this book is to provide an accessible account of some of the sculpture in the Ashmolean, its individual histories, and, where possible, to fit it into the much bigger picture.

Some of these threads are observational: take feet for example. In a period of anatomical reductionalism, sculptors' treatments of feet seem idiosyncratic but remarkably specific:

look at the vestigial but entirely supportive feet of Maillol's little bronze nude (PLATE 2), more seat than feet. Or those sticking out of Kenneth Armitage's *The Bed* (PLATE 16); and there are others. Or backs: those of Epstein's *Head of the Dreamer* (PLATE 7), and Winifred Turner's *Reclining Woman and Child* (PLATE 4), where both sculptors have allowed themselves a freedom in which the form and the medium speak for themselves in a more relaxed and immediate way. This also, incidentally, poses a problem of display, for backs are often as interesting as fronts.

Other observations came to notice during the luxury of the curatorial activity of handling the pieces, for example the two distinct and quite different treatments in the work of two women using clay. Ursula Tyrwhitt's sketchy head of *Gwen John* (PLATE 33), for all its clumsy pushing and scraping of the malleable material, achieves a highly charged rendering of personality, while Lucile Passavant's seated nude (PLATE 3), far from being modelled, is a cast in which the medium, a clay slip, has been poured into a mould before firing to create an anonymous, un-particularised archetype. Only by weighing them in the hand do we realise that the former is heavy, the latter light. When handling Brian Kneale's severely abstract and very heavy piece *Trio* (PLATE 20) subtleties of form and surface, at risk of being lost in the static nature of display and photography, become obvious. This is a piece to be picked up and turned in the hand, like a rarity of the Renaissance in the cabinet of some seventeenth-century amateur, so determinedly three-dimensional is it.

There are three problems in approaching sculpture that are not so fundamental to painting. The first, undoubtedly, is inherent in its three-dimensional character: no series of photographs can adequately describe the object, nor yet its scale, the space it demands, or its relationship to the viewer. Paintings suffered similarly in appreciation until the development of quality colour photography and, as we enter an age of mass access to video and DVD, it is to be hoped that this bar to a full appreciation of sculpture will have become as anachronistic as discussing paintings from the sepia postcards of the 1920s and 30s.

The second is that, generally speaking, painters have been painters, at least until the twentieth century. Titian, Turner, and Monet painted, and their work can be considered consistently in the two-dimensional. Sculptors, however, have always worked in both two and three dimensions and in a variety of media, so to focus on one at the expense of another is to produce a lop-sided account. Some artists, like Picasso, Matisse or Baselitz, defy categorisation as either painter or sculptor, others, like Hepworth, produced important work in two dimensions, by way of relaxation after the day's carving; while Moore used drawing and printmaking to develop ideas. Some, like Maillol, are remembered first and foremost as sculptors (FIG. 2); others, like Leon Underwood, experimenting throughout a long working life, are harder to pigeonhole.

The third problem, which is perhaps linked to this element of experimentation is the medium itself. While painting is largely about the application of pigment to a flat surface with

a brush, sculpture encompasses a variety of materials using very many tools, skills and complex processes which usually but not always involve more than one person and raise the whole touchy business of replication.

The Nude

Bare, naked, disrobed, unclothed, exposed, stripped, unclad, *au naturel*, undressed. These are the words provided for 'nude' by the thesaurus on the laptop on which this essay is being tapped out. None of them are, however, equivalents for the niceties of aesthetic convention enshrined in the word itself, and three of them are in effect in direct opposition to that aesthetic, and express an implied if latent violence. It was this, quite as much as their paganism, that offended the puritan and iconoclast of the seventeenth century in the 'pictures [referring to figure sculpture on tombs] of naked men and women ... the

FIG. 2 Aristide Maillol (1861–1944), *Pyrénées Orientales*, c.1895. Oil on canvas. Signed and inscribed with title. Bequeathed by Lt. Col. G.E. Bouskell-Wade, 1972.161. A1068

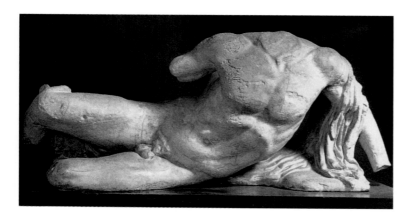

FIG. 3 Plaster cast of the *Ilissos*, from the West Pediment of the Parthenon (British Museum). Presented by Lady Chantrey, 1842.

opposite, left
FIG. 4 G.B. Piranesi (1734–1818), *One of a Pair of Candelabra* (detail), 1769–75. Marble. Presented by Sir Roger Newdigate, 1777.
NBP 77

memories of the heathen gods and goddesses with all their whirligigs' that John Weever inveighed against in *Ancient Funeral Monuments* (1631). Yet it was that very paganism, the association with the classical world of myth and legend, which clothed the often startlingly naked subject matter of both painting and sculpture with respectability for the next three hundred years.

In similar, if more ironic, vein, Sir Walter Scott, witnessing the removal of works of art from the Louvre in 1815, remarked on French 'attachment to these paintings and statues, or rather to the national glory which they conceive them to illustrate ... as excessive as if the Apollo [Belvedere] and Venus [de Medici] were still objects of actual adoration' (*Paul's Letters to his Kinsfolk*, 1816). Napoleon's campaign in Italy had, as elsewhere, been marked by an unprecedented cultural rapacity, which focused, in the Treaty of Tolentino of 1797, specifically on the masterpieces of the ancient world to be found in Rome, Florence, and Venice. The admiration for the aesthetic achievements of Greece and Rome informed, to an

overwhelming extent, the development of secular Western Art after 1540, as the Catholic Church relinquished its religious and cultural hegemony of Europe.

The Ashmolean, despite its location in a university of medieval origins, is not a Musée de Cluny or a Cloisters: the Gothic is significantly ignored here while the core collections bear witness to the avidity with which works of antique sculpture, albeit anonymous and replicated in innumerable versions, copies, and casts were collected and restored (FIG. 3). They range from the collections of Thomas Howard, Earl of Arundel, who, in 1613, was one of the earliest of Grand Tourists in Rome, to those of Sir Roger Newdigate, the agent through whom the Arundel Marbles came to Oxford in the mid eighteenth century, and who himself presented the pair of candelabra reconstituted by Piranesi from pieces found at Hadrian's Villa in 1769 (FIG. 4). In the nineteenth century the Museum acquired the entire studio of Sir Francis Chantrey, who, on his death in 1841, was the most distinguished emulator of the classical world of the day (FIG. 5). Chantrey's casts after the antique and his own studio casts were regarded as fitting for display in C.R. Cockerell's Greek Revival building. The acquisition by gift and bequest of C.D.E. Fortnum's collection of Renaissance bronze masterpieces after the antique reinforced the bias. Some, like the *Spinario* and the *Venus* (FIG. 6) were straight translations, others, such as *Pan Listening to Echo*, were inventions inspired by the classical world.

It is against this background that the work

14

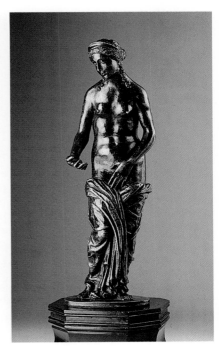

of Aristide Maillol in the Ashmolean collection should be regarded and appreciated. Maillol was born at Banyuls-sur-Mer, in the Pyrénées Orientales. After an initial training in graphic design and in the textile industry in Perpignan, he went to Paris in 1882 where he met Gauguin and Bourdelle, and came under the classicising influence of Puvis de Chavannes. Four years later his plans to set up a small tapestry manufactory in Banyuls were destroyed by temporary blindness, and he returned to Paris. He exhibited as a painter with the Nabis from 1893 to 1903, and Maurice Denis became a close collaborator and long-term friend. Around 1900 he began the experiments in carving and modelling for which he is now best known. His obsession with the female form, to the extent

that it became the dominating subject of his expression whether drawing, printmaking or sculpting, began tentatively with examples such as the *Seated Nude* (PLATE 1). This version, a cast in terracotta, has a schematised, somewhat unconfident quality which suggests that it may be early. It owes more to intimate domestic interior sculpture by Degas, of women washing, drying and combing their hair, and to Renoir's sculpture, than to any directly classical inspiration. Within the collections, however, it resonates with a number of Renaissance bronzes, in particular with Barthélémy Prieur's *Nymph cutting her toenails*, of about 1565, from the Fortnum Collection (FIG. 7).

Ambrose Vollard, who had successfully launched Picasso the year before, set up a kiln

above, centre
FIG. 5 Sir Francis Chantrey (1781–1841), Model for *Mrs Dorothy Jordan and her children*, 1831. Unfired clay. Bequeathed by Miss Jones, 1863. NBP 456

above, right
FIG. 6 Attributed to Francesco Francia (*c*.1495–1517), *Venus*. Bronze. Bequeathed by C.D.E. Fortnum, 1899

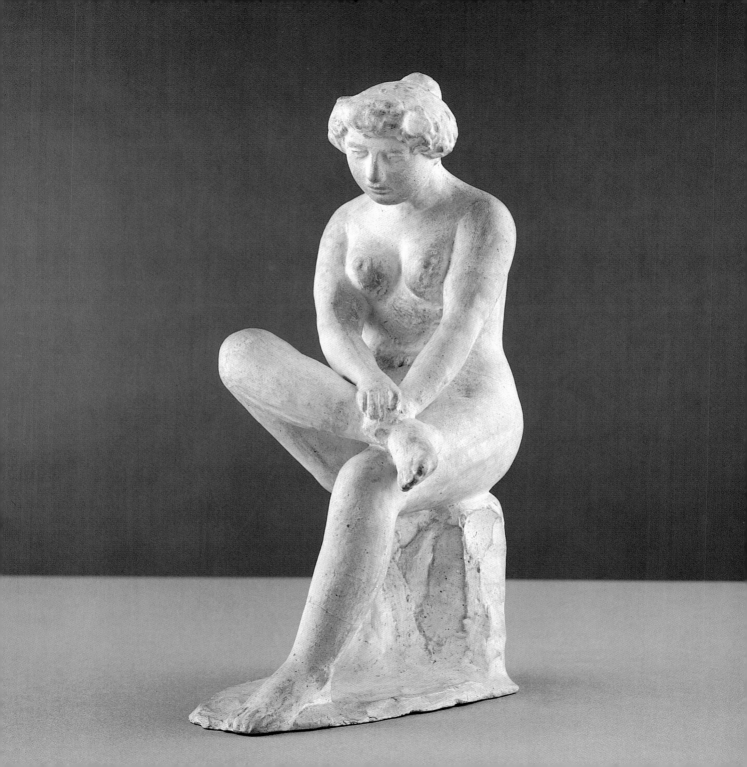

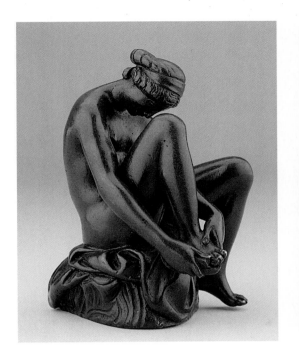

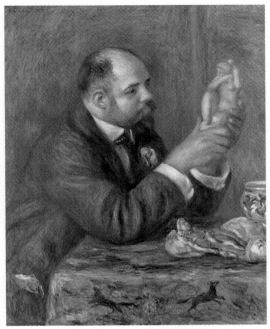

far left
FIG. 7 Barthélémy
Prieur (1535–1611)
*Nymph cutting her
toenails, c.*1565.
Bronze. Presented
by C.D.E. Fortnum,
1888. NBP 326

left
FIG. 8 Pierre-
Auguste Renoir
(1841–1919), *Portrait
of Ambrose Vollard,*
1908. Oil on canvas.
Samuel Courtauld
Trust, Courtauld
Gallery, London

at Villeneuve-Saint-Georges in 1902, and persuaded Maillol to allow him to produce editions of little figures such as the *Seated Nude*, in both terracotta and bronze. In Renoir's portrait of 1908 the dealer sits gazing fondly at just such a small Maillol (FIG. 8). Vollard then successfully exhibited the terracottas in the sculptor's first solo exhibition, in Paris in June of that year. It is doubtful that Maillol was entirely happy with the results, because he subsequently produced his own editions. Though Vollard had agreed to do them in editions of ten, the status of the various editions is confused as most of them are unnumbered.

The unnumbered *Kneeling Nude* (PLATE 2) is known in both terracotta and bronze on this

scale. Stamped with a monogram under the right leg as you look at it, or 'proper left', it probably belongs to the 'Edition Vollard'. It pre-dates a life-size version commissioned by one of Maillol's German patrons, Kurt von Mutzenbecher, in 1905. This plaster is in the Kröller-Müller Museum, Otterlo and appears, surmounting a chimneypiece and flanked by murals by Maurice Denis, in a photograph of an interior designed by Hugo Van de Velde for the Dresden Decorative Arts Exhibition in 1906. It is a transition piece from the manner of Degas and Renoir to the monumentality of the later work, an example of which, the *Flore* of 1912, is sited outside the Maison Française in Norham Gardens in Oxford. The classicising, almost ideal, quality so apparent from the front

PLATE 1 Aristide Maillol, *Seated Nude, c.*1902

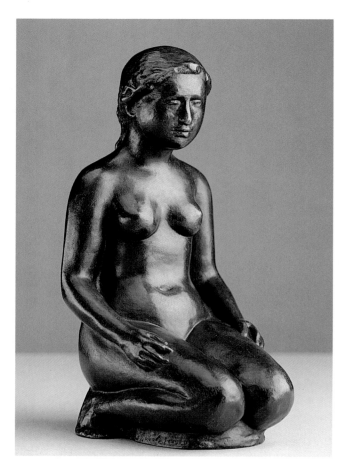

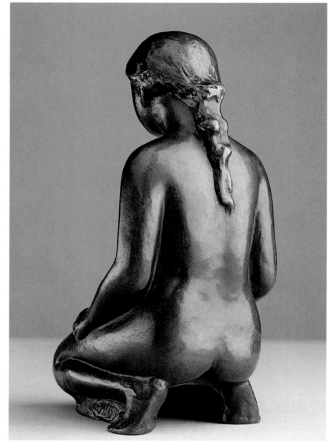

PLATE 2a and b
Aristide Maillol,
Kneeling Nude,
*c.*1905

and in profile, and in the girl's demure attitude, might be said to belie its modernity.

With hindsight, however, one may discern a tendency to abstraction, or at least to a reduction of form, in the Ashmolean *Kneeling Nude*. The surprise in the figure is in the back, and in those feet. The figure appears to balance on improbably long toes in a yogic position, and what arrests the sculptor is the space between, an inherently modern concern. That Maillol was so concerned is borne out by his numerous drawings, etchings and lithographs of crouching and kneeling women seen from the back. The slight roughness of finish and loss of detail in the little figure gives it a quality lacking in the highly-finished, life-size version in bronze now in the Musée Maillol, Paris, and contributes to its modernity. Maillol's achievement was to reinvest the classical idiom with a contemporary vigour that influenced the work of others, including Gaudier-Brzeska, Moore and Epstein.

PLATE 3 Lucile Passavant, *Seated Nude*

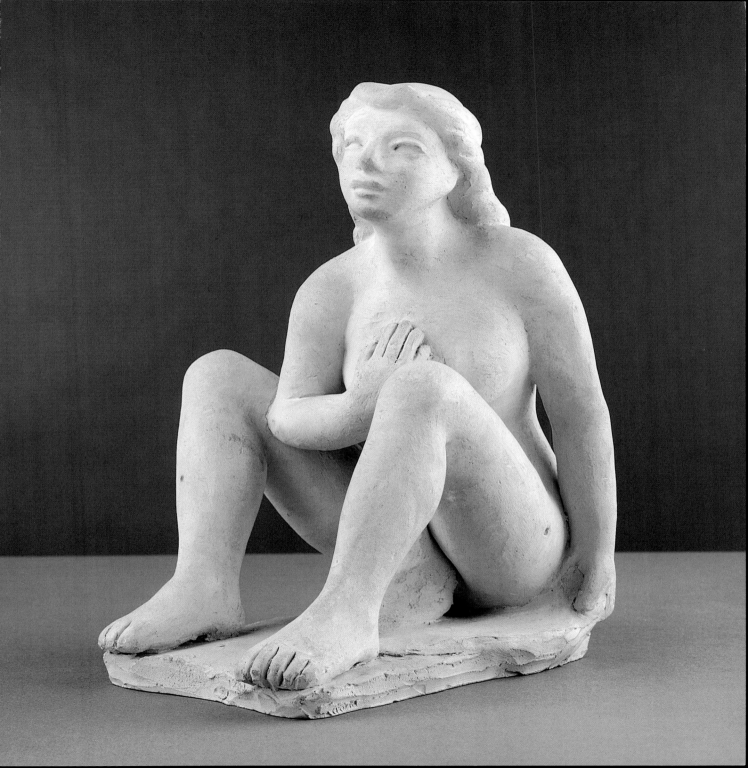

FIG. 9 Alfred Turner, *Peace* 1914

Both pieces by Maillol came into the Ashmolean collection as part of the important Hindley Smith bequest of early twentieth-century works, almost entirely paintings, received by the museum in 1939. It is unlikely that Frank Hindley Smith would have acquired them before 1919, when Maillol's name was firmly established, largely through large-scale war memorials. He had shared an exhibition with Matisse at the Leicester Galleries in London, in 1919. Hindley Smith was a member of a Lancashire cotton-milling family who had begun by collecting Corot and the Barbizon School before the First World War. It was only after the war, when the dealer Percy Moore Turner introduced him to Roger Fry, that Turner and Fry successfully encouraged Hindley Smith to buy what are now some of the most important paintings in the Museum, including works by Picasso, Matisse and Braque.

A further related work came to the Ashmolean with the Christopher Hewett Collection in 1985, and it is perhaps no more than a coincidence that both collectors, singular men of advanced aesthetic sensibilities, shared a passion for Proust. The terracotta *Seated Nude* (PLATE 3) by Lucile Passavant must date from between 1954 and 1964. Passavant was a pupil and model of Maillol's, who had posed as the central figure in the Tate's *Three Nymphs*, and had collaborated in illustrating Horace and Ovid, after his drawings, for the Cranach Press in 1929 and 1930. As Maillol's pupil, Passavant took his advice: 'Stay simple, but don't be afraid of being gentle' (quoted in C. Roger-Marx). Passavant's subject matter, scale and

means of casting echo those of Maillol's earliest experiments. The cloth or towel is more a reference to bathers, antique and modern, than a nod to modesty and, in bringing the unparticularised type right into the middle of the century, Passavant maintained a continuum rather than creating a reaction.

Another female sculptor who maintained that continuum was Winifred Turner. She was the daughter and granddaughter of sculptors: her father, Alfred Turner, was, like Gilbert Bayes, a second-generation adherent of the New Sculpture, and trained under the modeller W.S. Frith at the South London Technical Art School, Lambeth. Much of his work is associated with monuments (FIG. 9) or memorials and, often sited in former colonies of

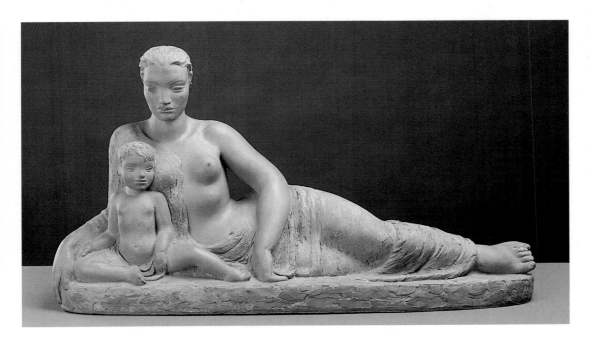

PLATE 4a and b
Winifred Turner,
*Reclining woman
and child*, 1930s

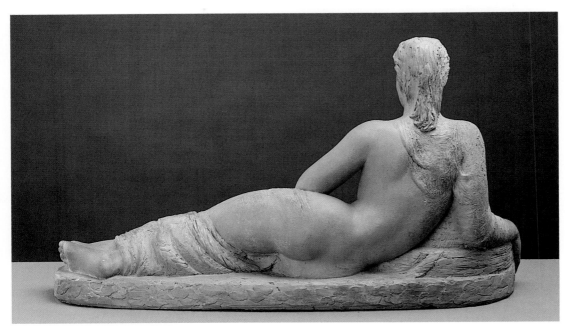

the British Empire, has failed to maintain his reputation. Alfred's daughter went first to the Central School from 1921 to 1924, when she began exhibiting at the Royal Academy and enrolled at the Academy Schools. She later taught with Richard Garbe at the Central School, whose antipathy to modernism was notorious. Turner was often her own model, using a large studio mirror, which may have dictated the frontality of much of her work. The front-and-backness of this method of observation is very evident in a work from the 1930s, *Reclining woman and child* (PLATE 4). It has the calm, hieratic quality of an early Etruscan terracotta tomb figure. The smooth surface finish of exposed flesh, comparable to a

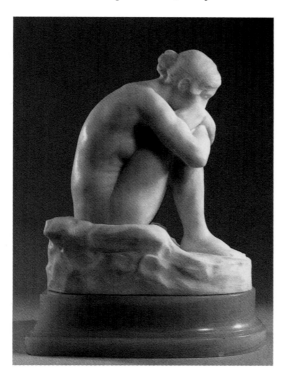

terracotta cast by Dalou, is in contrast to the tooled hair and the patterning and tasselling of the Hispano-Philippine shawl, that ubiquitous prop of all artists' studios in the first half of the century. Much of her work has affinities with the work of Wilhelm Lehmbruck, perhaps by way of Carl Milles. In its smooth outlines and yogic positions, it appears indebted to the less heroic compositions and subject matter of Ivan Meštrovič in the 1920s and 30s, whose work Turner may have seen at the Fine Art Society in 1925 when, as a student, she was taking all the prizes at the Royal Academy Schools just down the road.

The artistic tensions at work in the years before the First World War are illustrated by three works related by their classical allegiance. In 1909 Edgar Mackennal exhibited *Sappho* (FIG. 10), a small marble, at the Royal Academy. Although more particularised in finish and in composition more compressed, this piece, particularly in the integral rock, owes its immediate inspiration to Rodin, in whose studio Mackennal had worked in the 1880s and 90s. It belongs however in the tradition of the sitting, kneeling or crouching female nude type, a Venus or nymph of antiquity.

So does the massive female described in Henri Gaudier-Brzeska's drawing *Seated Nude I* (PLATE 5), drawn in an evening life-class in Chelsea in 1912. Gaudier's drawing method was entirely different from the then customary practice. In a letter to his Polish companion Sophie Brzeska, he described the difference: 'The people in the class are so stupid, they only do two or three drawings in two or three hours, and think me mad because I work without

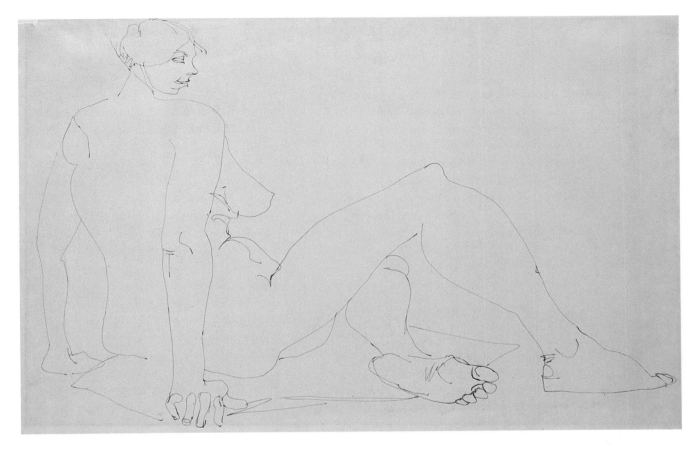

stopping – especially while the model is resting, because that is much more interesting than the poses'(17 November 1912, quoted in R. Cole). On occasion Gaudier made as many as two hundred studies, each taking not more than a minute. The Ashmolean example, where the model appears to be resting, is so close to a version now in the University of Warwick Collection that it may derive from the same model on the same evening. There can barely have been time for the model to turn her head, let alone shift her vast limbs. It was this speed

of observation and the emphasis on line that came a few years later to characterise Leon Underwood's teaching practice in the early 1920s (PLATE 26 and FIGS 22 a, b, c).

Born at Saint-Jean-de-Braye, Orléans in 1891, Gaudier won French government scholarships to Britain and Germany to study what today we would call business management. In 1906 he lived in Bristol and attended the Merchant Venturers Technical College. Gaudier spent some of his time in the Zoo, drawing animals, and in the City Museum,

PLATE 5 Henri Gaudier-Brzeska, *Seated Nude I*, 1912. Pen and ink. Purchased, 1992.7

23

where he may have encountered his first Polynesian artefacts, such as green soapstone amulets or tikis.

Back in Paris in 1910, he began to sculpt, and met Sophie Brzeska, whose name he added to his own. He settled in London in 1911, and only returned to France to join up on the outbreak of war in August 1914. Like another émigré sculptor, Michael Rysbrack (1694–1770), who came to London two hundred years earlier in a similar period of change, all his profoundly radical work was carried out in this country. Gaudier-Brzeska became a friend of T.E. Hulme and Ezra Pound and worked closely with Jacob Epstein, another émigré who found the climate of change in pre-war London conducive. Days spent in the British Museum, which housed ethnographic collections side by side with artefacts from the ancient civilizations of Assyria, Egypt, Greece and Rome, produced a fusion of imagery and style that has continued to influence sculptors to this day. Gaudier-Brzeska's *Seated Woman* (1914, Musée d'Art Moderne, Paris) springs from the antique type of the Crouching Venus. Its composition recalls that of the terracotta by Maillol in Renoir's portrait of Vollard (FIG. 8), and the link with Maillol is borne out by the fact that another work by Gaudier-Brzeska, the *Sepulchral Figure* (1913, Tate Gallery) was sold in the 1950s as by Maillol. Its treatment is, however, entirely new and derives from observation of other cultures. Gaudier-Brzeska died at Neuville-Saint-Vaast on 5 June 1915. On one occasion he passed the tedium of the trenches by taking the butt of an enemy Mauser and making a knife carving of a design

'through which I tried to express a gentler order of things' (*Vortex Gaudier Brzeska (written from the trenches)*. Published in *Blast*, July 1915; quoted in R.Cole).

Another piece in the collection, Sir William Reid Dick's *Crouching Nude* (PLATE 6), might be described as a poignant curiosity, but it underlines the point being made. For the sculptor has incised in the soft chalk: 'W. Reid Dick/1916/Cabaret Rouge/Souchez', and as it happens Souchez and Neuville-Saint-Vaast, where Gaudier-Brzeska died, are a few kilometres apart on the edge of the Vimy Ridge, just north of Arras. Reid Dick had told the figure's first owner that he had persuaded a young soldier in the Kensington Regiment to pose for it. Be that as it may, the source is the Venus type, inspiration for both Maillol and Gaudier-Brzeska, expressed in the manner of Rodin, in the little figure emerging from the lump of chalk thrown up by trench digging.

Reid Dick had trained at Glasgow School of Art, where casts after the antique provided instruction for students until the 1970s. After the war Reid Dick received numerous official commissions including the Kitchener Memorial Chapel in St Paul's Cathedral (1925) and the lion surmounting Reginald Blomfield's Menin Gate at Ypres. He became the Queen's Sculptor-in-Ordinary for Scotland, but since the 1930s has rarely been accorded a mention in surveys of twentieth-century sculpture. The crouching nude was bequeathed by Major Thomas Bouch, an undergraduate at Magdalen College, Oxford (1901–3), whose bequest, sixty years on, established a fund which, a further thirty years later, provided the money to buy the drawing

PLATE 6 William Reid Dick, *Crouching Nude*, 1916

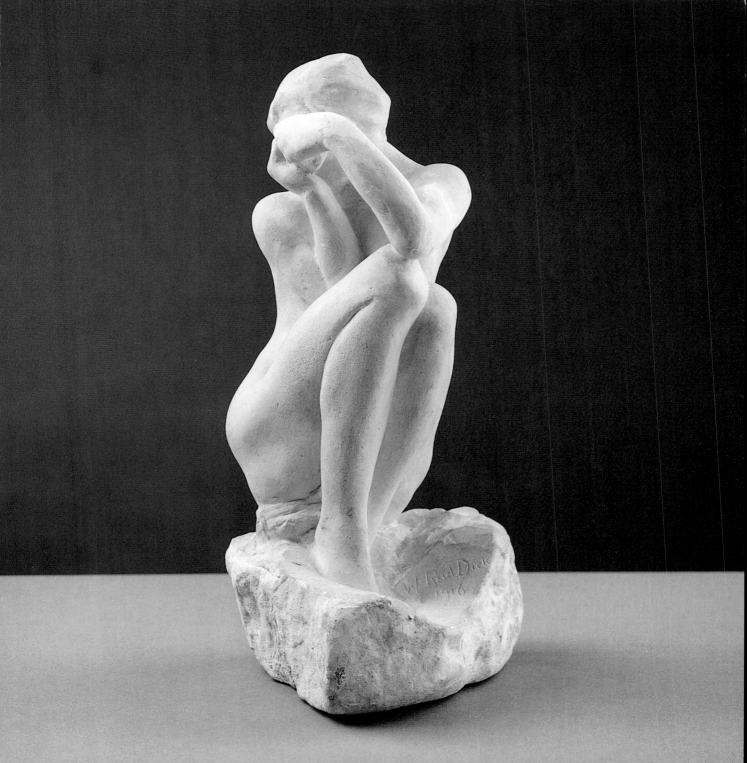

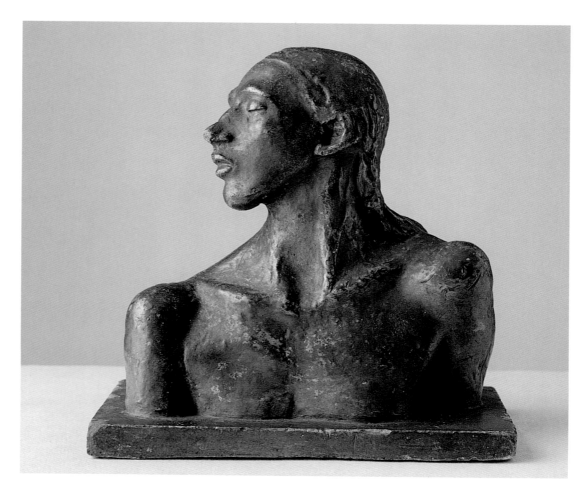

by Gaudier.

Gaudier-Brzeska was greatly influenced by Jacob Epstein while in London. Born in New York of first-generation Jewish-Polish immigrants, Epstein went to Paris in 1902 at the age of twenty-two, worked under Jean-Paul Laurens at the Académie Julien, and met Rodin. In 1905 he moved to London, becoming a naturalised British citizen five years later. When Gaudier visited him in his studio to see the completed monument for Oscar Wilde's tomb in the Père Lachaise Cemetery, Paris, in June 1912, Epstein was already acknowledged as the leading avant-garde sculptor, having suffered the storm of criticism that surrounded the completion of eighteen figures for Charles Holden's Medical Association Building in the Strand in 1908. One can only surmise that what was found most offensive about the figures was that they were far from ideal, being portraits of

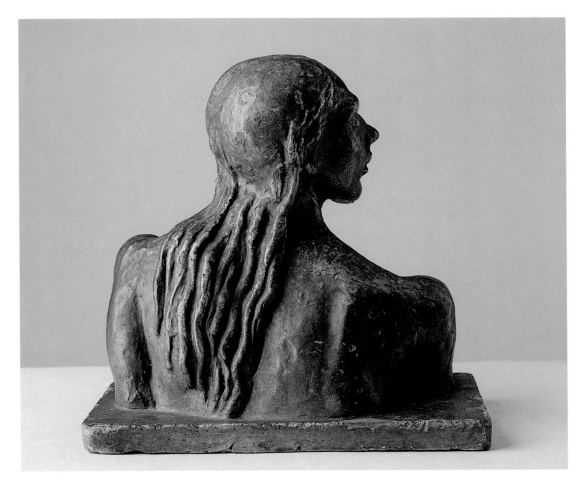

middle European peasants, whose inspiration must have been the work of Ivan Meštrovič. Had they been nymphs, clothed or nude, clinging decorously to the building in the manner of Alfred Drury's exactly contemporary figures on Aston Webb's Cromwell Road façade of the Victoria and Albert Museum, they would almost certainly have gone unnoticed. Prudery, chauvinism, bigotry and anti-Semitism were the hallmarks of much of the popular reaction

to Epstein's work, throughout his long working life.

In *Head of the Dreamer* (PLATE 7) the Ashmolean has a plaster fragment of the small bronze figure entitled *Nan The Dreamer* by Epstein. The complete version of 1911 (FIG. 11), parallels in three dimensions life-class poses captured by Gaudier-Brzeska the following year, and may, like them, be seen as a learning exercise. The model Nan Codron, a gipsy and

FIG. 11 Jacob
Epstein, *Nan the
Dreamer*, 1911.
Bronze. Bradford
Art Galleries and
Museums

right: FIG. 12 Alfred
Drury, *Crouching
Nude*, 1912

gipsy way of life. A further dimension, that
Epstein may have exploited in the figure of *Nan*
was one of race and class, deliberate on the
part of the sculptor, but touchy for the general
public with their preference for a glamourised
view of female beauty. It was Gaudier-Brzeska
who had written to Sophie Brzeska declaring
that Rodin's St John was more beautiful than
the Venus de Milo for 'he belongs to my own
time, is in my own epoch, he has a twentieth
century workman's body just as I see it and
know it' (19 May 1911; quoted in Lewison,
p.28).

Epstein was in Paris in 1912 to oversee the
installation of Wilde's tomb and met Picasso,
Brancusi and Modigliani. On his return to
London he joined the loosely-aligned group
that included Gaudier, William Roberts, David

professional model, was the subject of
numerous studies, both drawn and modelled in
the years 1909 to 1911. What distinguished these
studies from nudes such as Mackennal's
Sappho (FIG. 10) or Alfred Drury's *Crouching
Nude* of 1912 (FIG. 12), was their naturalism.
Epstein's studies of Nan are portraits, not
anonymous classical personifications. He
divested the nude of its academic acceptability,
and presented a body and face that was far
from the ideal, but the way it was. The gypsy's
long limbs, elongated to the point of
exaggeration, were inspired by Rodin yet
devoid of the expressiveness associated with the
late nineteenth-century Symbolism of which
Rodin's work was so much a part.

Epstein may have met Nan through his
friendship with Augustus and Dorelia John, and
Henry and Euphemia Lamb, who shared a
bohemian life-style and a romantic view of the

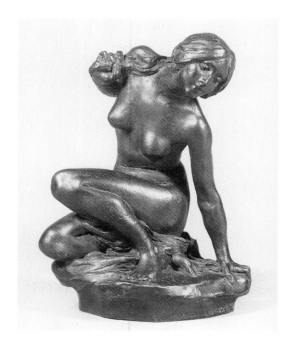

28

Bomberg, C.R.W. Nevinson and Percy Wyndham Lewis, and directed his attention away from naturalism and modelling to developing the techniques and aesthetics of direct carving inspired by remote civilisations.

Head of the Dreamer had belonged to Mrs R.M. Bernhard Smith, who ran the Twenty One Gallery, Adelphi, and gave Epstein his first solo show in December 1913. The relationship between sculptor and dealer was not an entirely happy one, and years later Epstein tried to reclaim this plaster cast and prevent further casts being taken from it. Mrs Smith later claimed that the plaster cast was a present from Epstein, and in 1962 she offered to have it cast in bronze for the Ashmolean Museum. This did not happen, but in 1991 the plaster was presented by Mrs Smith's niece in her memory. The work is, like so much of the work of the twentieth century in the Ashmolean, a transitional piece. It is small and domestic like the Maillols, and as such is in the tradition of Dalou, Degas and Renoir. It is not, however, typical of Epstein's work as a whole, which, dominated from the beginning by the heroic, is work on a colossal scale.

The Heroic

The Heroic is a tradition that flies in the face of the classical and, stylistically, it can be triumphalist. Developing out of nineteenth-century, specifically German, romanticism, with its emphasis on Wagnerian myth and legend, it became in the twentieth century identified with a narrow, exclusive form of nationalism, adopted as Social Realism by both sides of the totalitarian spectrum, Fascism and Communism.

Gilbert Bayes, the son and sibling of painters, was both prolific and precocious, exhibiting for the first time at the Royal Academy at the age of seventeen. Much of his work, usually in the form of friezes, was designed for architecture. This may explain why his is not a household name, for who can recall him as the creator of the eleven foot high *Queen of Time* clock on the façade of Selfridges, Oxford Street, London (1926–31), or the frieze for Lords Cricket Ground (1934) entitled 'Play up! Play Up! And Play the Game'. Certainly the anonymity that attaches to architectural sculpture was one of the reasons why Henry Moore tended to avoid commissions for it.

Only eight years older than Epstein, Bayes had trained at the Royal Academy Schools from 1896. He was of the generation, encouraged by George Frampton and influenced by Alfred Gilbert, that was heir to the movement which the critic Edmund Gosse labelled 'The New Sculpture'. The ideas and ideals to which Bayes adhered, across a long working life, merged the highly expressive European symbolist movement and an emphasis on modelling, with an entirely pragmatic approach in the application of sculpture to industry and architecture. This had its antecedents in the Pre-Raphaelites, William Morris and the Arts and Crafts Movement.

Bayes exhibited *Sigurd* at the Royal Academy in two versions in 1909 and 1910. In the first Sigurd holds up the ring Advaranant, which the dragon Fafnir had guarded, in the second the sword Gram or Wrath, with which

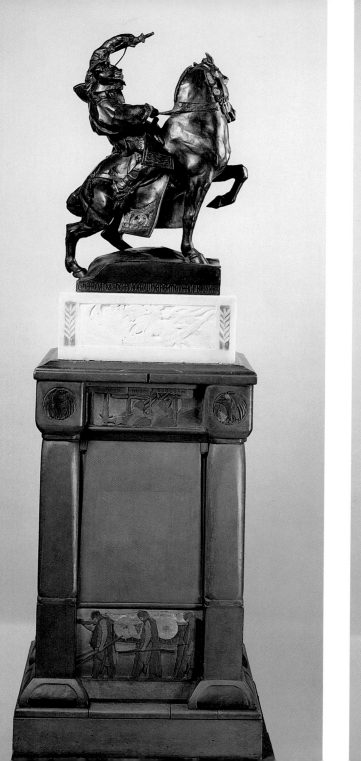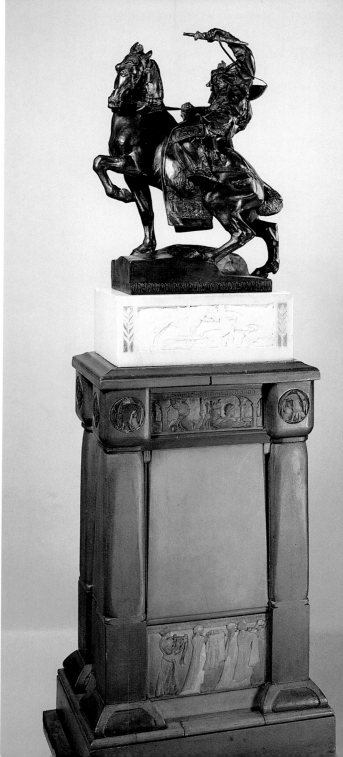

PLATE 8 Gilbert Bayes, *Sigurd with Gram Sword* (detail), 1910

he had slain the dragon (PLATE 8). The piece is full of emblematic detail: Sigurd, hero of the Norse Saga, the *Elder Edda*, rides Grey Fell; the dragon Fafnir is represented on his helm-crest and saddle-cloth which also has, in enamel, the emblem of the Volsung, the Branstock tree. The front upper panel of the plinth represents the Nibelung brothers Gunnar, Hogni and Guttorm, and below is the funeral of Sigurd. On the back are the three women in Sigurd's life, Brynhild,

PLATE 8 Gilbert Bayes, *Sigurd with Gram Sword*, 1910

Grimhild and Gudrun, and the child Sigurd being held up to King Elf. The capitals are decorated with Thought and Speech, Odin's twin ravens. The inventive use of mixed media, bronze, marble and enamelling and, in the plinth, wood, gesso, paint and gilding, were characteristically employed by adherents of the New Sculpture.

The Rev. J.W.R. Brocklebank, who had matriculated at Christ Church in 1889, and become Rector of Longbridge Deverill in Wiltshire, bequeathed the Museum a remarkable group of thirty-five bronzes. Most of them had been purchased directly from the sculptors themselves, and included four by Rodin, a dozen by Alfred Gilbert and others by Frederick Leighton, F.W. Pomeroy, Onslow Ford, and other sculptors of the New Sculpture movement. Brocklebank saw the first version, of *Sigurd with the Ring*, at the Royal Academy in June 1909, and purchased it for £150. He also commissioned the plinth, which is unique. The plinth was not completed until March the following year, for what he clearly thought was the exorbitant sum of £50. Brocklebank later considered the second version of the bronze, *Sigurd with Gram Sword*, an improvement, and a swap was effected, with Brocklebank retaining the marble base from the first version.

In the context of European Symbolism, with its emphasis on myth and destiny, body and spirit, this is as Symbolist as British sculpture ever gets. That it was seen contemporaneously as dynamic, not recidivist, is clear from its inclusion in the British Section of the International Fine Arts Exhibition in Rome in 1911. Even the purchase of the second version

for the Tate from the Royal Academy Summer Exhibition of the previous year by the Trustees of the Chantrey Bequest, who were then under scrutiny from the Curzon Enquiry into the National Gallery of British Art, amid accusations of a self-serving patronage, is evidence of the establishment's view of its modernity.

Commentators have seen its dynamism as stylistically in sympathy with Futurism (Beattie, p.240) and have remarked on it as a transitional work between the New Sculpture and the post-war memorials of Charles Sargeant Jagger and others (Penny III, p.7) With the hindsight of almost a hundred years, however, *Sigurd* may be seen as the end, not the beginning of a stylistic era. The quotation, in Lombardic script around the base of the bronze, is taken from William Morris's translation of the *Edda*, *Sigurd the Volsung*:

He who would win to the Heavens and be as the Gods on high
Must tremble nought at the road and the place where men-folk die.

With its implied Nietszchean glorification of war and death, this is a signpost to the cul-de-sac into which sculpture of this type rode on the eve of the outbreak of the Great War. Bayes' colossal equestrian groups *Offerings of Peace and War*, commissioned in 1916 for the main frontage of the Art Gallery of New South Wales (completed 1926, Sydney), were, in spirit, out of date and out of touch. After the cataclysm of the First World War, in which heroism was destroyed by the realities of trench warfare, a new language was needed to replace both the

heroic attitudes of the New Sculpture and the mechanistic aggression of the Vorticists. In the 1920s some sculptors found it in a classical if deeply stylised revival, so stylised that much of it can be associated with the term Art Deco. The exhibition at the Tate of the work of the Swedish sculptor Carl Milles in 1927 was highly influential. Milles was seen by contemporaries as a modernist, and his *Europa and the Bull* (1923–4), purchased for the Tate from the exhibition, inspired a number of emulating works, among them Charles Sykes's *Europa* (PLATE 9). In sculptural terms Sykes's bull owes something to the late Romano-Iberian cult of Mithras and the bull, and even late Dynastic Egyptian bulls such as the basalt type in the Ashmolean (FIG. 13).

This sudden change of attitude is surely one of the factors in the almost complete eclipse of the reputation of the sculptor Ivan Meštrović. It is difficult today to appreciate fully the celebrity status achieved by this Croatian-born artist in Europe before the First World War. It is indicative of this eclipse, that while Gaudier-Brzeska and Naum Gabo were included in the survey exhibition *British Sculpture in the Twentieth Century* at the Whitechapel Art Gallery in 1981 and 1982, Meštrović was not. Yet arguably his was the better-known and more influential name in this country in the first quarter of the century. He exhibited in Britain as early as 1906, aged twenty-three, in the Dalmatian pavilion of the Austrian Exhibition at Earls Court. Solo exhibitions followed in London, Leeds and Glasgow in 1915, and at the Twenty One Gallery in London followed by Bradford, Glasgow and Edinburgh

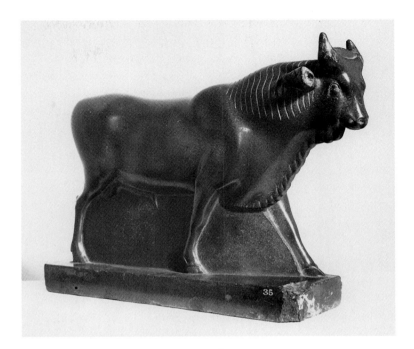

in 1918, and London again in 1925. The exhibition at the Fine Arts Society in London in 1925 was a source of inspiration to a number of artists including Leon Underwood, Gertrude Hermes and the wood engravers Bernard Rice and Claire Leighton.

Born in the last days of the Austro-Hungarian or Habsburg Empire, in Slovenia, the son of migrant Croatian agricultural workers, Meštrović was apprenticed to a master-mason at Split before attending the Academy of Art in Vienna. He was exhibiting with the Secession Group in 1903 at the age of twenty and, in 1907, he exhibited sixty-two works with the Vienna Secession. That same year he met Rodin and moved to Paris. Meštrović was acclaimed at the International Exhibition in Rome in 1911 where, in the

FIG. 13 *Sacred Bull*, Probably 30th Dynasty/2nd Persian Period. Basalt. Cook Collection, 1947.293

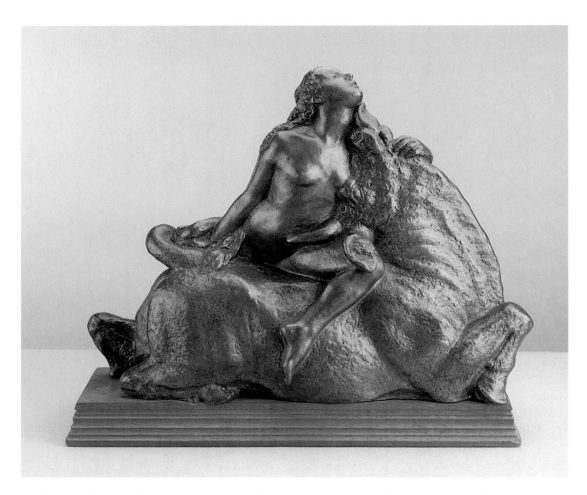

Serbian Pavilion, he showed works inspired by the Pesmas or Hero Songs of the Yugoslavs and the national epic, the Lay of Kosovo. Among the work exhibited was the colossal, never-to-be-completed version of *Marko the king's son on his horse Šarac* (PLATE 10), which owes an obvious debt to classical friezes and the myth of the Lapiths and Centaurs, with the more recent influence of Barye (FIG. 14) and Bourdelle. In a review of the exhibition in the *Manchester Guardian* (20 June 1911), James Bone hailed Meštrović as 'the New Master'. On the outbreak of war, and the defeat of the Serbian army in 1914, Meštrović came to London, where he was given an exhibition at the Victoria and Albert Museum. It was the first exhibition ever given to a living artist at the museum and the motives for it, on the part of the organisers, among them Sir Arthur Evans, former Keeper of the Ashmolean, were not perhaps entirely cultural

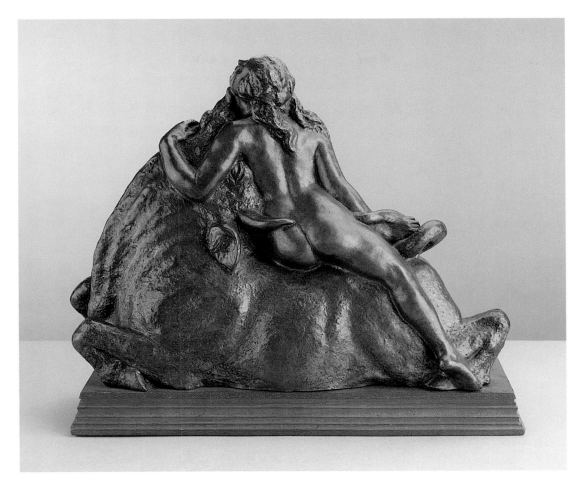

and artistic. It was inaugurated on 24 June by
Lord Robert Cecil, Under-Secretary of State for
Foreign Affairs, and was clearly part of a
propaganda campaign in support of the
Southern Slavs' attempts to liberate themselves
from the Austro-Hungarian Empire. In 1918 an
exhibition of Meštrovič's work in Paris, which
coincided with the Peace Conference at
Versailles, undoubtedly contributed to the
establishment of Yugoslavia as an independent

nation state. Even the gift by Prince Paul of
Yugoslavia of this piece to the University of
Oxford should be seen in the light of nationalist
diplomacy.

This identification of the work of Meštrovič
with Yugoslavian nationalism, the
disappearance of Yugoslavia behind the Iron
Curtain in 1945, and the recent, brutal
resurgence of Balkan nationalism has
contributed to the demise of Meštrovič's

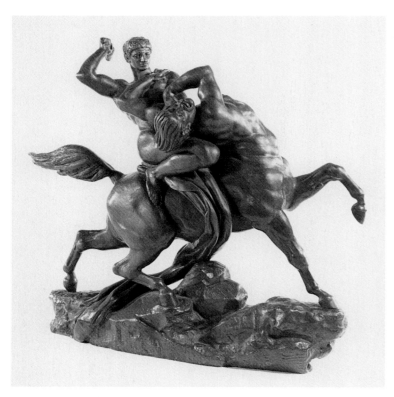

the exhibition devoted to Meštrovič, at the Brooklyn Museum, New York in 1924. He wrote, 'the position occupied by Ivan Meštrovič in contemporary art is midway between the conservatives and the restless, questing radicals. It is, relatively speaking, the position maintained by the Frenchman Maillol, and the Anglo-American Jacob Epstein.' It is significant that forty years on, the champion of the Modernist movement, Herbert Read, makes no mention of Meštrovič in his survey *A Concise History of Modern Sculpture*, while Epstein is discussed only once, and then only in passing as an influence on Henry Moore.

The idea for a memorial to the dead of both wars originated at the 1944 Trades Union Congress at Blackpool and, at the end of the war, the General Council pursued a vision in which a new headquarters would be itself a memorial, and at the same time provide an opportunity to stimulate interest in architecture and the arts. In 1955 Epstein accepted a commission from the Trades Union Congress for a memorial figure destined for the inner courtyard of the new headquarters, Congress House in Great Russell Street, London, designed by the architect David Aberdeen.

The maquette, which survives in a plaster cast version at Congress House and in two bronzes (PLATE 11), was accepted 'after some discussion' at the TUC General Council on 24 August 1955, when it was shown with a model by Bernard Meadows, winner of an open competition for a piece for the front entrance. The sketch model differs markedly in treatment, mood and feeling from the final outcome carved in stone, not just as a result of

reputation in Europe. Imprisoned in 1941, he left Yugoslavia to settle in the United States, and became Professor of Sculpture at Syracuse and then, in 1947, Notre Dame University.

As early as January 1912 D.S. MacColl wrote, in *The Nineteenth Century and After*, 'the school that is now occupying critics and youthful artists is a different one – a school of simplified and massive forms, more architectural than Rodin's, represented by the Frenchman Maillol, the Servian [sic] Meštrovič and the semi- English Epstein.' This grouping was repeated and rephrased, with a subtle but significant shift of emphasis, by Christian Brinton in his introduction to the catalogue to

PLATE 10 Ivan Meštrovič. *Marko the king's son on his horse Šarac*, 1911

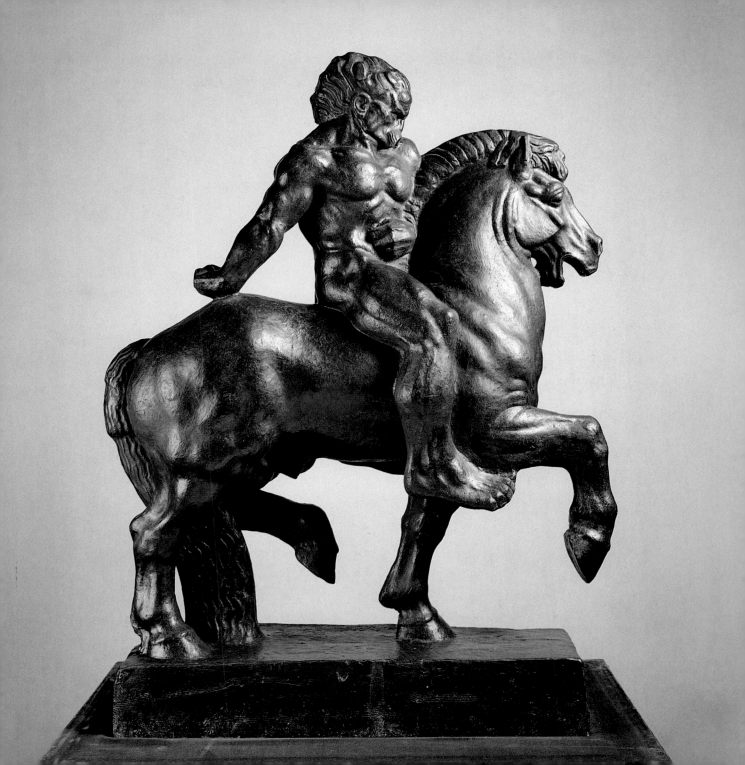

PLATE II Jacob
Epstein, *Maquette
for the TUC
Memorial*, 1955

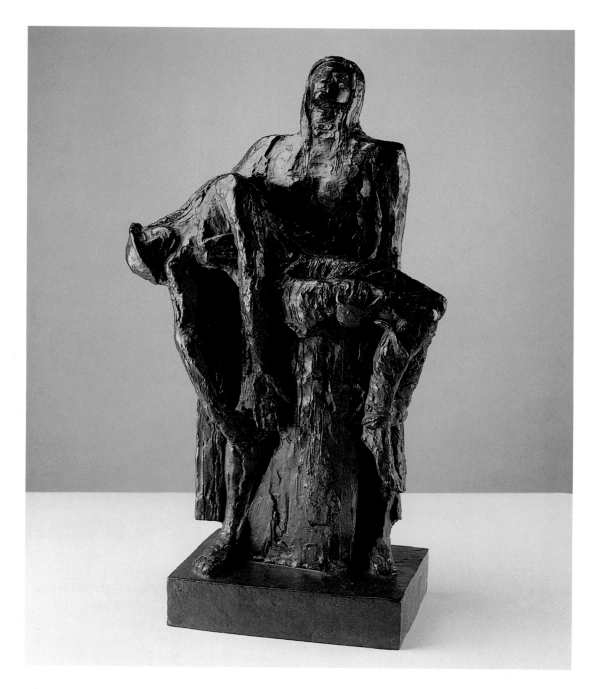

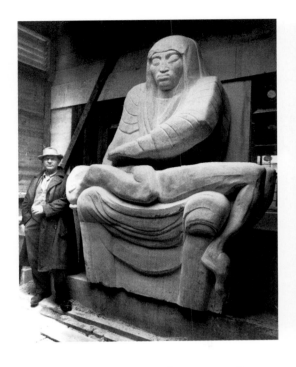

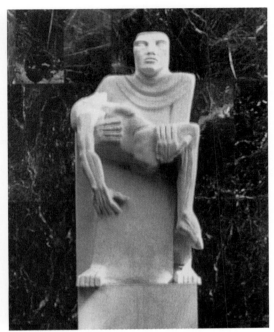

the transference of an idea from one medium to another, or from the change of scale. This may even have been deliberate, for Epstein was a veteran of many controversies surrounding his work for public places, and his modelled work was always the more literal and obviously accessible.

The stone was carved in situ, as was Epstein's *Night* on the London Underground headquarters (FIG. 15) whose imagery it develops. The TUC Memorial is a tour de force, for the sculptor, who at seventy-five employed an assistant for the first time, worked on the scaffold planks and complained only of the noise of the building work all round him. The original impressive backdrop of green marble and mirror glass has subsequently been replaced by an altogether less successful surface of green glass mosaic chips (FIG. 16). The primary sources for the figure are Michelangelo's two Pietàs: the seated grieving Virgin in St Peter's, Rome, a seventeenth-century bronze version of which is in the Fortnum Collection (FIG. 17), and the *Rondanini Pietà* (1555, Museo Civico, Milan). Epstein had already used these for *Night*. The helmeted figure in the arms of the standing figure in the maquette also recalls Donatello's long-haired *David*, slain or mortally wounded. However, the air of Renaissance resignation and restraint in the model, the suggestion of the figure of the dead or wounded being offered up, is abandoned in the carving for a much more profound pathos, and, full of raging grief, a

FIG. 17 After
Michelangelo,
Pietà. Bronze.
Presented by
C.D.E. Fortnum,
1888

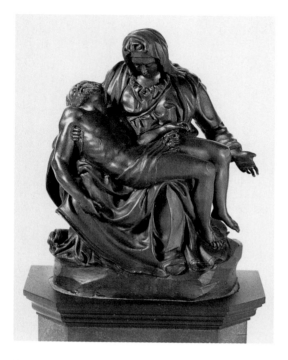

latent aggression in the elemental mother. The detail is confined to feet and hands, giving it a timeless quality. Epstein had returned for inspiration to Oceanic art, the mask-like faces coming from a reinterpretation of Fang and Marquesas Island heads in his own extensive ethnographic collection, while the source for feet cleft from the block may be standing figures from Papua New Guinea. In the TUC Memorial, Epstein has created a modern Niobe. According to legend Niobe was punished for her impiousness in seeking divinity. Unable to save her children from Apollo and Diana's arrows, she watched all fourteen die and was herself turned to stone.

This was the last stone Epstein cut in a long, prolific and controversial career. All Epstein's monumental works explored the nature of religious feeling and human suffering and endurance. From the figures on the BMA Building, in 1908, his most provocative pieces had been carved from stone. Stone, the medium prescribed in the TUC's original brief, dictated the form, and in so doing elevated the work from a memorial fixed to a time and a place to something which, to paraphrase the sculptor's own expressed aspirations, is heroic, classical and enduring. Shorn of detail the image becomes universal.

The Airmen

In 1952 the British Pavilion at the 26th Venice Biennale was filled with sculpture by sculptors of the generation following Moore and Hepworth, who had themselves been shown at the Biennale in 1948 and 1950 respectively. Entitled 'New Aspects of British Sculpture' the exhibition was selected by Herbert Read, Philip Hendy and John Rothenstein, the latter two being Directors of the National Gallery and the Tate respectively. It was a benchmark exhibition, a rare convergence of the establishment and the avant garde, and never before can such relatively unknown artists have received the applause of an international audience. In the exhibition's introduction Herbert Read coined the telling phrase 'the geometry of fear' to describe what he discerned as a unifying vision, although it is an expression that the artists themselves have struggled against ever since. Three of the sculptors in that group are represented in the Hewett collection: Kenneth Armitage, Geoffrey

Clarke and Bernard Meadows. The two latter were airmen, having served with the RAF during the war. As Alan Bowness has pointed out (1995), theirs was a generation that had been brought up under the threat of Fascism and war, survived the fear of death and defeat, discovered the horrors of the concentration camps and were now faced with the Cold War and possible annihilation. It was the generation whose members were, in the theatre, labelled Angry Young Men, those for whom John Osborne's *Look Back in Anger* (1956) spoke, a

PLATE 13 Bernard Meadows, *Four studies entitled Crab*, 1952/79. Pencil and watercolour. Monogrammed and dated. Presented by the sisters of Christopher Hewett, 1987.158, 162–4

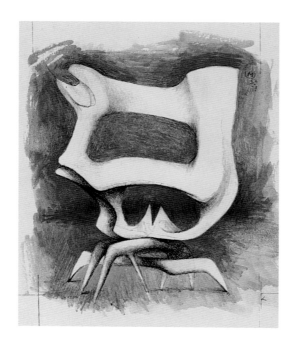
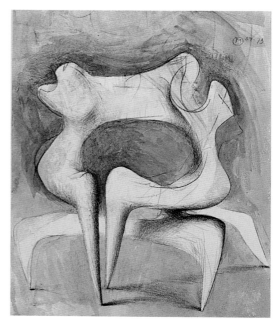
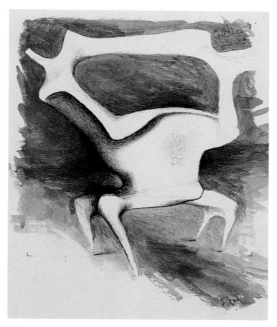
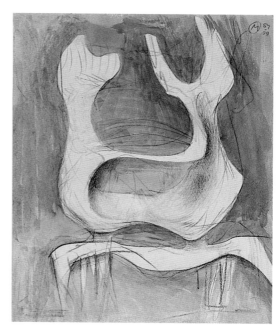

generation which rejected the heroic in any form. The work of artists of this generation was profoundly affected by personal experience, and attempted to reconcile the human condition with new expressive forms. In the face of indelible images from Belsen and elsewhere the human form lost its god-like classicism. Memorable images were created, Anthony Caro's *Woman waking up* (1955, Arts Council Collection), John Skelton's *Aftermath of War* (1965, Herbert Art Gallery, Coventry), and Ralph Brown's *Clochard* (1955–6, artist's collection), but powerful though many of these were they seemed to drive sculpture into a dead end. Some, like Reg Butler, turned for inspiration to prehistoric forms such as the Willendorf Venus (Natural History Museum, Vienna), and others to mechanisation, as in Eduardo Paolozzi's *The Philosopher* (1957, British Council). Images of pilots and flying men, and of the legend of Icarus's flight recur, notably in this country in the work of Michael Ayrton and Lynn Chadwick, and abroad in César's *The Man of St Denis* (1958, Tate Gallery) and Germaine Richier's *Bat-man* (1946, Wadsworth Atheneum, Hartford, Connecticut). Many turned to the animal kingdom and developed imagery with associative values: birds of prey, fighting cocks and bulls. Birds, beasts and humans merged and fused, taking on each other's characteristics and developing a distinctive quality of their own. This is evident in the dozen drawings and three bronzes by Bernard Meadows in the Hewett Collection (pls.12 and 13).

On leaving school at sixteen, Meadows was apprenticed first to a coachbuilder and then to an accountant. In 1934 his parents allowed him to go to the Art School in his home town of Norwich, where the training consisted of drawing from casts of antique sculpture. He went on to London, but was at first refused a place at the Royal College, where the Professor of Sculpture, Richard Garbe, was opposed to modernism. He attended Henry Moore's life-modelling classes at Chelsea, and was invited by him to be a paid assistant during the vacations. Under the more sympathetic aegis of Gilbert Spencer, Professor of Painting, Meadows was eventually accepted at the Royal College in 1938. His time there was interrupted by the outbreak of war, a spell as a conscientious objector and, on volunteering for the RAF, five years on active service, mostly spent in Cochin, South India, and on the Cocos Islands in the Indian Ocean.

At the end of the war Meadows returned to the Royal College, this time to the Sculpture Department under Frank Dobson and John Skeaping. He was one of twelve sculptors exhibited by the Arts Council at the Festival of Britain, and was among those who won international acclaim at the Venice Biennale in 1952. Meadows was by then teaching at Chelsea, where Elisabeth Frink was among his students, and they provided the props for a one-night performance at the Albery Theatre of Sartre's *Les Mouches*, in 1951. Like Meadows, Frink was concerned with the human condition, and the work of these sculptors in the early 1960s bears comparison. Their subject matter explored the theme of power and the bully, Meadows being inspired in his *Armed Busts* and *Tycoons* directly by Michelangelo's

Brutus and Renaissance images of *condottieri*. Meadows showed again in the Venice Biennale of 1964, this time with the painter Roger Hilton and the younger Pop artist Joe Tilson. He was Professor of Sculpture at the Royal College of Art for twenty years from 1960 to 1980, when he became Acting Director of the Henry Moore Foundation.

The numerous drawings by Meadows in the Ashmolean collection were made as a way of generating ideas which, though more complete than sketchbook studies, were often never carried out. In them Meadows reaches towards finality, working up ideas and giving them colour washes to accentuate the forms (PLATE 13). This attention to presentation marked all Meadows' work, and perhaps stemmed from his time as Moore's assistant, when he became known as 'the boy'. He had learnt to carve at Moore's cottage Burcroft, at Kingston in Kent, working on the Hornton stone *Recumbent Figure* (1938, Tate Gallery) and the elmwood *Reclining Figure* (1939, Institute of Arts, Detroit). Ten years later he carved most of one of Moore's *Three Standing Figures* destined for Battersea Park. However it was in experimenting with Moore in the business of casting, on a kitchen primus stove at Burcroft in the years leading up to the Second World War, that Meadows found his metier. Together they cast in lead from small models in wax, plaster and clay, made by Moore in the evenings, when the exacting task of carving out of doors was over for the day. Later Meadows set up a foundry at the Royal College and oversaw every aspect of the process himself. The labourious nature of the technique and his personal commitment to it militated against a large or prolific output. The surface finish is crucial to an appreciation of Meadows' work and he took the business of achieving it very seriously indeed, as the present writer knows from first hand experience: Meadows insisted on removing the larger version of *Help* (1966), from the City Museum and Art Gallery in Bristol, where the loving hands of the public had, in ten years display, darkened the surface to a patina and altered the balance between the matt and shiny surfaces. The sculptor re-polished and lacquered the piece himself before returning it for display.

The surreal element in Meadows' late work – he had exhibited at the 1st International Surrealist Exhibition in 1936 – comes from his continued use of crab forms 'as human substitutes', and as 'vehicles expressing my feelings about human beings'. He went on to say that they were 'less inhibiting; one is less conscious of what has gone before and is more free to take liberties with the form and to make direct statements than with the human figure: nevertheless they are essentially human' (quoted in Bowness, 1995). It is this subliminal reference to the human form, the fusion of masculine and feminine, of implicit sexuality, that may first strike the viewer. It is salutary to note how close is the formal relationship between Meadows' *Black Crab* (1951, Tate Gallery), for which there are reworked drawings in the Hewett Gift (PLATE 13), and Giacometti's *Woman with her throat cut* (1932, Scottish National Gallery of Modern Art, Edinburgh). However, crustaceans, whose soft insides are protected by external skeletons,

flailing pincers, and compound eyes always alert to danger or food, scuttling backwards or sideways while facing forward, provide an explanation for the imagery and its sources. The work by Meadows in the Ashmolean, which all dates from the 1970s, is characterised by the frontality of composition. It is not work to be seen in the round, and it is we the viewers who are being watched. This contradictory state is enhanced by the ambiguity of medium, for we know it to be metallic, but structure, form, and finish suggest it should be soft.

These works are evidence of the sculptor's abiding preoccupation with the idea of fear and vulnerability. Their titles, *Help, Frightened Figure*, and *Watchers* underline this pervasive quality (PLATE 12). The anthropomorphism evident in all work by Meadows stems from his wartime experience in the Cocos Islands where crabs in particular made a profound impact on the hitherto untravelled young man. Time and the boredom and fear of war would have hung heavy but for observation of these extraordinary creatures in their thousands, permanently in a state of flight or fight, their armoured bodies dominated by huge, globular, oscillating eyes. It could be said that the crab became, for Meadows, a metaphor for modern man. The photograph of Meadows in which the sculptor confronts a vast crab is well chosen as the frontispiece to Alan Bowness's monograph.

This tendency to anthropomorphism, for creatures to be imbued with human characteristics, is evident too in the work of Meadows's pupil, Elisabeth Frink. She had lived through the war on the East Anglian plain among North Sea-facing aerodromes, and had been sent away to the West Country where she saw Exeter and Exmouth bombed. Her age and sex denied her first hand experience as an airman, but nevertheless flying left an indelible mark on her vision and on the imagery of her sculpture. As a student at Chelsea School of Art, Frink was not included in the group shown at the Biennale, but versions of her first work, *Bird*, were bought by the Tate that year, and by the Arts Council in 1953. Frink submitted work to the ICA's International Sculpture Competition, 'The Unknown Political Prisoner' in 1952 and won a prize. She taught successively at Chelsea and St Martin's Schools of Art and at the Royal College. In 1967, finding the pervading emphasis on abstraction inimical, she went to live in France. She returned in the mid-1970s, becoming a Trustee of the British Museum in 1974 and a Royal Academician in 1977. In 1982, like Hepworth before her, Frink was made a Dame of the British Empire. Like Epstein and Clarke, but unlike many other contemporaries, she was happy to undertake commissions with either a religious or political significance, and made her sculpture *Tribute* (1975) for Amnesty International. Her first major commission was for the lectern for Basil Spence's Coventry Cathedral, consecrated in 1962. Frink's lectern evolved out of the traditional eagle lectern of Spence's early proposals by way of studies in the London Zoo, and with the aid of kindling sticks set into the plaster for feathers. It was a logical expression of the ideas she had already formulated in her *Bird, Harbinger Bird* and *Birdman* series. A cast of the eagle was incorporated in the J.F. Kennedy Memorial in

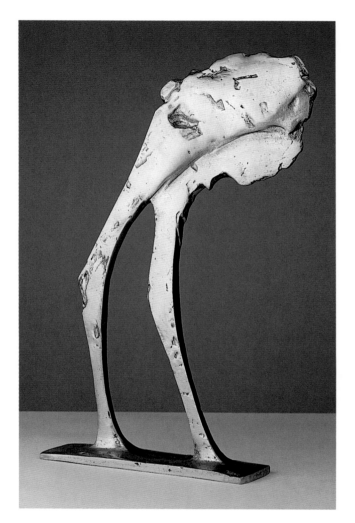
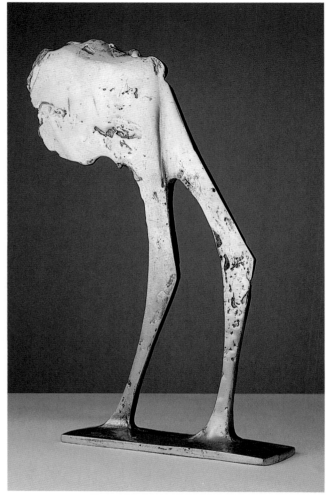

Dallas, Texas, in 1964. Frink's last commission was *The Risen Christ* for the Anglican Cathedral, Liverpool (1993).

There is a naturalistic strain running through Frink's work. She could produce sculpture in the great nineteenth-century *animalier* tradition, but she was also exercised, like Meadows, by a concern for the human condition. For that reason her work can convey a powerful message. Frink described her early bird imagery, to which she gave the ominous group title *Harbinger Birds*, as 'expressionist in feeling ... that is, emphasis on beak, claws and wings – they were really vehicles for strong feelings of panic, tension, aggression and predatoriness' (quoted in *Elisabeth Frink:*

46

Sculpture and Drawings 1952–1984). Mirage (PLATE 14) is a late example of the Bird imagery and, pared down to almost one dimension, is as reductionalist as Frink was ever to be. A drawing (PLATE 15), purchased in 1969, relates to the legend of the Minotaur, a subject that has carried a fascination for many artists, notably Picasso and Michael Ayrton, and was developed by Frink into a series of eight lithographs entitled *The Bull Fight* (1973).

Another example of what might be called this 'morphic' tendency in sculpture is found in the Hewett Collection in Kenneth Armitage's *The Bed* of 1965 (PLATE 16). Armitage also belongs to the generation of sculptors who came to prominence in the years immediately after the Second World War, he shares their broad concern for the condition of humankind

PLATE 15 Elisabeth Frink, *Man and Bull* 1968. Pencil and wash; 556 × 762. Signed and dated. Purchased, 1969.13

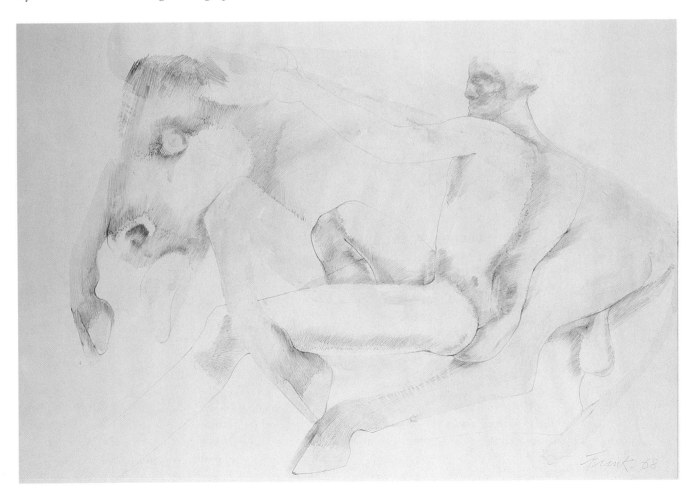

47

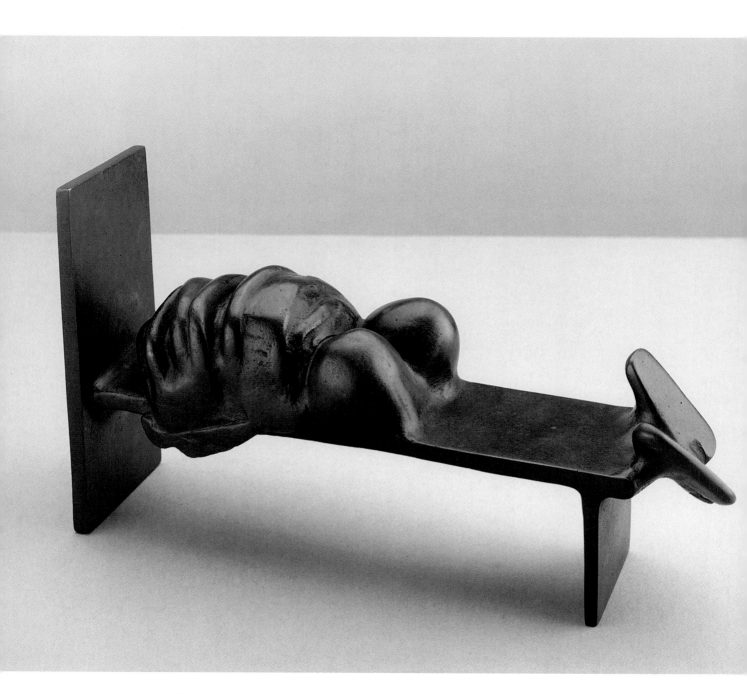

in the face of mass destruction. Armitage was born in Leeds and attended first Leeds College of Art from 1934 to 1937, and then the Slade from 1937 to 1939. He spent the war in the Army identifying tanks, and on demobilisation was appointed Head of the Sculpture Department at Bath Academy of Art, Corsham. At that point he destroyed his pre-war carvings and began to model in plaster work for bronze. He was among those included in the 26th Venice Biennale in 1952. From 1953 to 1955 he was Gregory Fellow at the University of Leeds. Armitage was shown for a second time at the Venice Biennale in 1958 with the abstract-

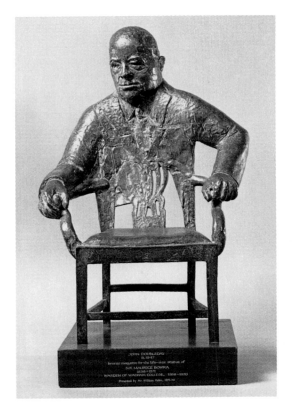

expressionist printmaker S.W. Hayter and the painter William Scott, who had been on the staff with him at Corsham. The exhibition was subsequently shown across Europe, and gave Armitage an international profile.

Until the late 1960s when he turned to the oak trees in Richmond Park for subject matter, Armitage's work centred on the human figure. Unlike Frink and Meadows, however it never entailed anthropomorphism. Armitage's figures do no more than flirt with abstraction, merging with the elements and morphing into objects, such as *Chairs* (1981) or, as here, a bed; for it was not feeling or mood, nor yet ideas, but the structure underlying things that interested him. *The Bed* is a *jeu d'esprit*, lighthearted, whimsical, as the artist described its genesis in seeing a friend pull the bedclothes angrily over her head. This particular form of morphism can, in other hands become unsatisfactorily mannered, as in John Doubleday's maquette for the portrait of Maurice Bowra (FIG. 18), completed for Wadham College, Oxford in 1977.

Abstraction

To be abstracted is to be not quite with-it, not connected or in touch with reality. An abstract, however, is also the core or kernel, the essence of something. It is somewhere here in the invisible space between these apparent opposites that so much of the art of the twentieth century exists. It is this contradiction that causes problems for appreciation and understanding of the purely abstract in art, confining it all too often to the realms of the cerebral and the ascetic. The pieces loosely

opposite: PLATE 16
Kenneth Armitage,
The Bed, 1965

left: FIG. 18 John
Doubleday,
*Maquette for Sir
Maurice Bowra*,
c.1977

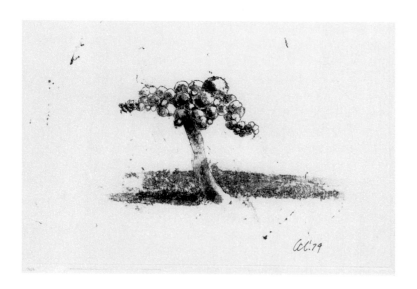

labelled 'abstract' in the Ashmolean collections
are not, with the possible exception of two, pure
abstraction. Most have clearly discernible roots
in the material or real world. All but Frink's
Mirage came into the collection in 1985 when
the sisters of Christopher Hewett (1938–1983),
presented 144 items consisting of paintings,
sculpture, prints, drawings and *livres d'artiste*,
in their brother's memory. Hewett had been at
the Ruskin School for two years before going to
the Royal College of Art in 1960, followed by
two years in Paris working for the architect
Roger Saubot. It was as an art dealer and
gallery owner, however, that Hewett made his
particular contribution. Most of the objects in
his gift had been exhibited in the Taranman
Gallery on Brompton Road, which he ran from
1974 until his death. Here he showed artists
from Europe trained in the post-war
abstraction of the School of Paris, among them
Nicholas de Staël. He also showed British

sculptors from the generation of Meadows and
Clarke who had in the 1960s lost popularity to
a new generation now working in steel plate,
fibre glass and plastic, including Anthony Caro
and Philip King.

Hewett's own aesthetic roots lay in the late
nineteenth century. The earliest exhibitions he
organised were devoted to Alphonse Legros,
Charles Shannon, and F.L. Griggs, and among
the objects that came with his gift to the
Museum were a sepia photograph of John
Ruskin and a copy of *Until This Last*. As a boy
at Bishop's Stortford College, Hertfordshire,
Hewett was influenced by the poet, writer and
champion of contemporary sculpture, Walter
Strachan, then Head of the Modern Language
Department, who became a lifelong friend. At
the Taranman Gallery (*Tar'n'man* translates
roughly from the Tuareg as 'that which pleases
the eye' or 'the soul') Hewett's taste developed
rapidly in the direction of post-war abstraction,
exemplified in the perfection he pursued in the
design and production of a distinguished series
of exhibition catalogues. It is perhaps indicative
of the pure, simplified, apparently non-
referential qualities of some of his artists' work
that a number of them were amongst the
earliest of their generation to be shown in
Japan in the 1970s. Hewett's collection has a
remarkable coherence, particularly the works
on paper, which, with the exception of the
drawings by Meadows, share a cool,
monochromatic palette, texture and
uncompromising abstraction.

The first sculptor Hewett exhibited was
Geoffrey Clarke, who as a young man had
made an impressive contribution to the

furnishing of Coventry Cathedral. The building of Coventry Cathedral was a permanent monument to the spirit of post-war regeneration, with its fusion of the Neo-Gothic and Modernist, a distinctive style labelled 'Vitalism' by Herbert Read. After initial training at Preston and Manchester Schools of Art, Clarke had been called up in 1943 and became an aircrewman in the RAF. On demobilisation he spent a year at Lancaster School of Art under Ronald Grimshaw, who encouraged his students to search museums and reference books for striking objects and images. For Clarke, as for many other British artists of the twentieth century, Samuel Palmer became an inspiration (FIG. 19). After an unhappy start in the anti-modernist atmosphere of the Printmaking and Sculpture Departments at the Royal College of Art, Clarke found himself in the Stained Glass Department in 1948 under the observation of the Rector Robin Darwin. Within two years he was collaborating with Keith New and Lawrence Lee on the ten nave windows for Coventry Cathedral. These were exhibited in the Victoria and Albert Museum in 1956, and Clarke continued to be associated with the ornament for the interior and exterior of the cathedral, culminating in the twelve-foot cast aluminium Flying Cross for the *flèche*, which was winched into place by helicopter in 1962. He had represented the Royal College with *Icarus* in the Transport Pavilion at the Festival of Britain in 1951, and in the following year was one of the sculptors whose work filled the British Pavilion at the 26th Venice Biennale. Other accolades came to Clarke early in his career, and more commissions followed. He was shown again at the Biennale in 1960, alongside Eduardo Paolozzi and Victor Pasmore. From the mid 1950s to the late 60s Clarke carried out some fifty architectural commissions, among them the Treasury Windows at Lincoln, the Chancel Screen for the Guards' Chapel, Wellington Barracks, London, and a welded iron wall-piece for the Time-Life Building, Bond Street (1952), to which building Henry Moore also contributed.

Clarke's work, in common with other sculptors of his generation, was characterised by two features. One was a search for a new symbolic language for sculpture, in his case a particular source of inspiration being the ideographic patterns of Sumerian seal-stones in the British Museum and botanical diagrams of seed-growth in the Natural History Museum. These objects, apparently abstract, had a meaning to be decoded or explained. The other feature of Clarke's work was his broad-minded, exploratory approach to medium and technique. In the post-war years when stone or marble and bronze were hard to come by and expensive, younger sculptors learnt to carve in plaster of Paris and polystyrene, to forge iron and to cast in aluminium. It was a period of a marked hands-on approach, as the entire process of production was carried on in the studio, rather than in a professional foundry. Clarke was in the forefront of this experimentation. He went on a welding course with the British Oxygen Corporation in 1950, organised by Robin Darwin as part of a series of practical links between industry and the Royal College, and thereafter set up his own

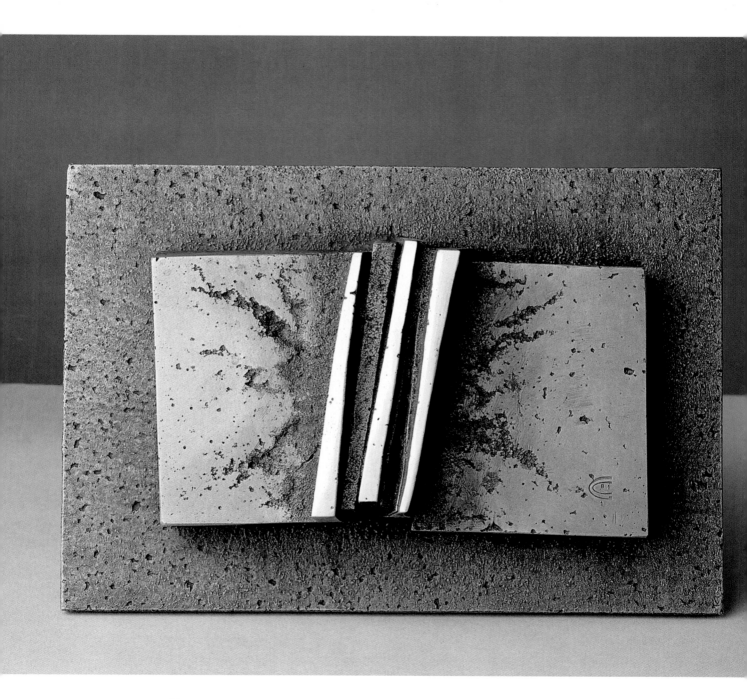

forge at the back of the College. He was a pioneer of the vaporisation technique of casting aluminium which he began to explore in 1957. This entailed carving or, more accurately, cutting the form into expanded polystyrene, which, in a manner similar to that of the ancient lost wax technique of casting in bronze, vaporised on contact with the molten metal. The use of polystyrene had a direct effect on form, colour and surface finish, introducing a new, even Mannerist quality to sculpture:

contrasts of highly polished, reflective surfaces with textured skin or hide-like ones. *Books* (PLATE 17), a small aluminium wall plaque, demonstrates exactly these qualities. Signed and dated 1981, this is the most contemporary piece yet to have entered the collections.

If *Books* is a pictogram, *Angle and supported bar* (1964) may be an ideogram (PLATE 18). This was shown at the Taranman Gallery in 1975 (CAT. 40), described as a maquette related to the *Battersea Series I*, *II*, and *III*, for the Open Air

opposite: PLATE 17
Geoffrey Clarke,
Books, 1981

below: PLATE 18
Geoffrey Clarke,
Angle and supported bar, 1964

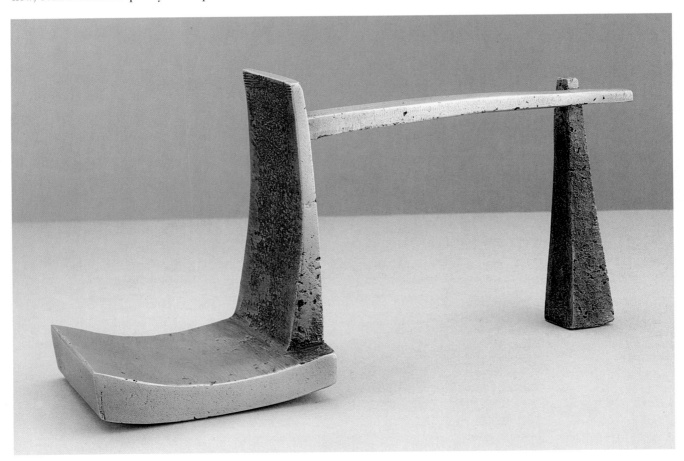

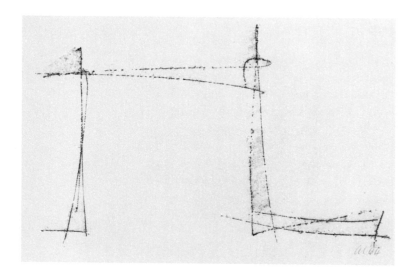

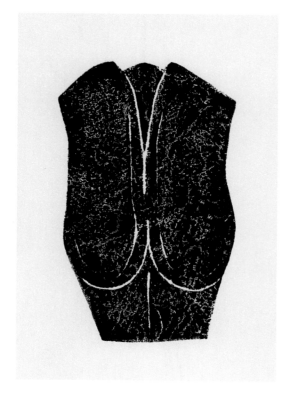

FIG. 20 Geoffrey Clarke, *Angle and supported bar*, 1964. Monotype on tracing paper; 251 × 382 (sheet). Signed and dated *GC'64*. Presented by the sisters of Christopher Hewett, 1987.102

right: FIG. 21 Raoul Ubac, *Torse* 1979. Slate relief print; 160 × 99. Signed and dated. Presented by the sisters of Christopher Hewett, 1987.199

Exhibition held in Battersea Park in 1964. Among Clarke's earliest freestanding work intended for sites in the landscape, it marked a departure from the dense symbolism of his relief work of the 1950s to more formal qualities associated with structure, as the simple, descriptive title suggests. It is a diminutive representative of a wider movement in sculpture, constructivist in appearance and facture, and intended to be shown outdoors. A monotype of the same year with the same title (FIG. 20) indicates a working method of the sculptor's, who early on developed a technique for 'fixing' his ideas at the design stage by transferring the drawing to print form, invariably monotype. This may have been the result of working in low relief, the two forms being related in their two-dimensionality and in their methods.

A similar process is at work in Raoul Ubac's *Ardoise VI* (PLATE 19). Here the small relief sculpture is potentially both an end in itself and a means to an end. It is both a three-dimensional object and a tool in achieving a two-dimensional image, a cross between a relief print and a monotype. The Belgian Raoul Ubac trained in Paris at the Ecole des Arts Appliqués from 1931 to 1934 and then at the Atelier 17 under S.W. Hayter. Working as a photographer in the surreal idiom of Man Ray, Max Ernst and others, Ubac used collage and photomontage to create and to distort images. These were published in the review magazine *Minotaure* and in 1938 he exhibited in the International Surrealist Exhibition. In the late 1930s Ubac was making montages from solarised nudes and, like Paul Nash, photographing stones. In

opposite: PLATE 19 Raoul Ubac, *Ardoise VI*

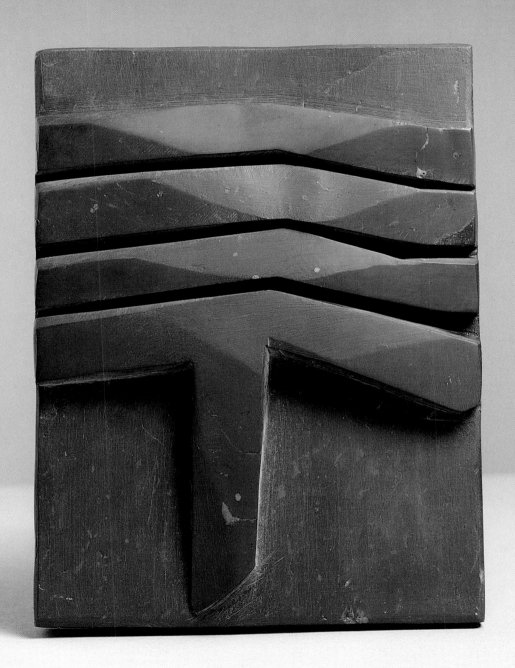

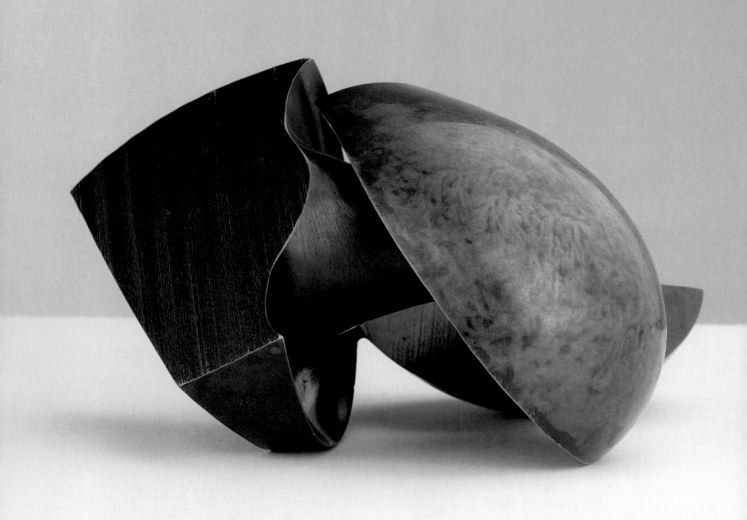

1942, in contrast to many British artists at the time, Ubac moved away from photography and Surrealism towards a pure form of abstraction. Travelling in the Haute-Savoie immediately after the War, he discovered slate as a medium, and continued to use it thereafter, often making prints from his carvings. There are twenty-six examples of these prints in the Hewett Collection (FIG. 21).

Ubac was a member of Cobra, the group of artists who took their name from the initial letters of Copenhagen, Brussels and Amsterdam. Other Cobra artists included Asger Jorn and Karel Appel who, like the Tachists of the Paris School, pursued a European strain of Abstract Expressionism based on graffiti, colour and texture. Ubac's work, however, simpler, cooler and in sculptural terms informed by the slate, has affinities with Pre-Dynastic, Pre-Colombian and Pre-Western cultures. It is difficult to date *Ardoise VI*. Ubac showed twenty-four slates at Taranman in an exhibition entitled simply *Ardoise* in 1980. These are recorded as being smoother and more polished than the earlier works, and it is likely therefore that the Ashmolean example dates from this late group. They are not as materially rooted as Clarke's *Books*, the medium alone providing the title, *Ardoise* meaning slate, the imagery being reduced to calligraphic signs or symbols. It is a coincidence, but worth remarking, that like Clarke, Ubac completed numerous commissions for ecclesiastical stained glass, at Ézy-sur-Eure, Varengeville, the choir of Nevers Cathedral and elsewhere, with Charles Marq. For both Ubac and Clarke the making of prints was integral to the process of making sculpture. The work of Ubac and Clarke clearly appealed to Hewett in indirect references to primordial man and landscape and in a talismanic quality.

A third piece in the Hewett collection is as cerebral or more so. This is a work whose title is as self-referential or descriptive as is *Ardoise*: Bryan Kneale's *Trio* (PLATE 20). Kneale's work characteristically has short titles, often musical, as in *Adagio* (2000), and with more than one meaning, as here, with which to express form. Kneale himself uses the word 'fuse' about this aspect of his work. Born and brought up on the Isle of Man, and deafened by a childhood accident, Kneale has always preferred to draw a thing rather than describe it in words. He attended the Douglas School of Art before going to the Royal Academy Schools where he won a Rome scholarship which took him to Italy from 1949 to 1951. His first exhibited works were paintings, and he was sought after as a portrait painter, but in 1959 he gave up painting for sculpture, making work in forged and welded iron and steel in a process he likens to drawing in three dimensions. Kneale continued to combine the practice of sculpture with teaching. Public commissions include the bronze gates for the west end of Portsmouth Cathedral and a relief for Westminster Cathedral. In the 1980s he returned to painting large canvases on which he drew the skeletal forms of birds and horses in a manner that recalls the anatomical drawings of Stubbs. He was Master of Sculpture at the Royal Academy from 1982 to 1985 and retired as Professor of Drawing at the Royal College of Art in 1995. Since then he has produced a large amount of

PLATE 20b Bryan Kneale, *Trio*, 1978

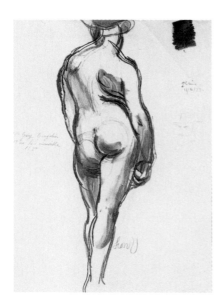 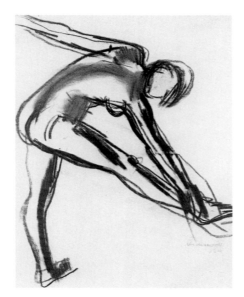 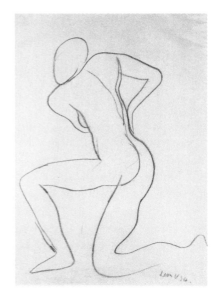

work which returns to bird forms and skeletal
shapes but which is quite as much about
internal structure, construction and surface
finish.

Trio is unique, made in 1978 and exhibited
at the Compass and New 57 Galleries in
Edinburgh and Glasgow in 1981, with a price
tag of £250. Made of solid bronze, it is
extraordinarily weighty for its size. Cut or sawn
and welded, the saw marks provide the surface
texture which, contrasting with the smooth
roundness of the various lobe-shaped forms, is
so much a characteristic of Kneale's work. Its
pure abstraction recalls Brancusi and Hepworth
and like their play on forms, it demands to be
seen in the round.

Henry Moore, Leon Underwood and Ossip Zadkine

In a survey of this scale, dependent on the
Ashmolean's collection, it is impossible to
encompass the work of Henry Moore
satisfactorily. His name has become
synonymous with twentieth-century Western
sculpture, so much so that it is difficult to
comprehend the deep antipathy that his work
continued to attract after the Second World
War. The vituperation against Moore was
expressed most notoriously by the President of
the Royal Academy, Sir Alfred Munnings, at the
Academy's Annual Dinner of 1949, in a speech
broadcast live on the radio the year after Moore
had won the International Prize for Sculpture
at the Venice Biennale.

In the 1920s Moore was committed to 'truth
to materials' and 'direct carving' which had

been an obsession common to Gaudier-Brzeska and Jacob Epstein before the First World War. Greece and Rome were 'the enemy', and Moore called for the 'removal of the Greek spectacles from the eyes of the modern sculptor ... [to] realise again the intrinsic emotional significance of shapes instead of seeing mainly a representational value' (quoted in James, p.14).

Like Epstein, Moore took inspiration from the ritual sculpture of other civilizations, in Moore's case that of Central America. He had read Roger Fry's *Vision and Design* (1920) where Fry acknowledged the importance of Pre-Colombian art in his essay 'Ancient American Art'. In London, while studying at the Royal College of Art (1921–24), Moore saw *Chac Mool*, the Mayan-Toltec Rain God, at the British Museum. He read Ezra Pound's critique *Gaudier Brzeska* (1916) and attended Leon Underwood's Brook Green School of Art. Underwood was teaching part time at the Royal College and his personality was such that students, among them Moore, Barbara Hepworth, Gertrude Hermes, Raymond Coxon and Vivian Pitchforth, gravitated to him in the evenings at 12 Girdler's Road, Hammersmith, where teaching revolved round life drawing. An Underwood School drawing of this period is

PLATE 21 Henry Moore, *Studies for Sculpture*, 1940. Pen and ink, watercolour, wax crayon and coloured chalks; 252 × 243. Signed and dated. Presented by the Contemporary Art Society, 1944.88

PLATE 22 Henry
Moore, *Two
Standing Figures*,
1940. Pen and ink,
black and coloured
chalks, wax crayon
and watercolour;
559 × 380. Signed
and dated.
Presented by Lord
Clark, 1980.135

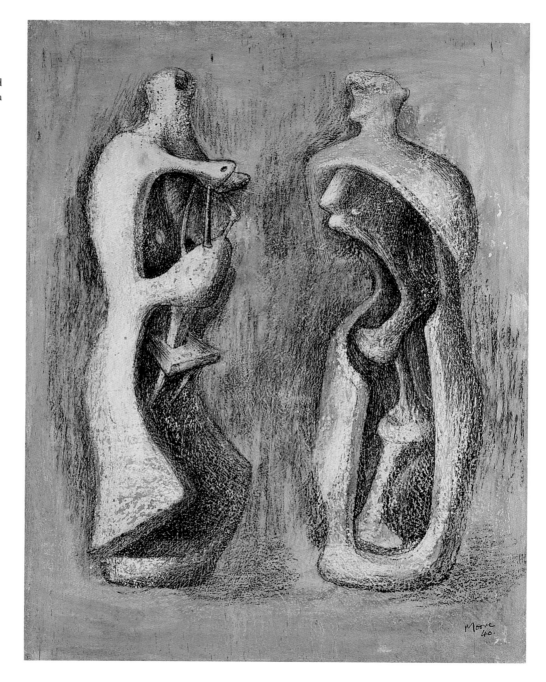

instantly recognisable (FIGS. 22 a, b, c), and Moore's early drawings deploy techniques derived from Underwood's teaching: the searching for form in volume by way of firmly wrought outline using coloured chalks and wash.

Drawing remained an important part of the exercise of making sculpture for, as Moore himself said, it was a help, tapping ideas, sorting and developing them. It was quick, useful as a study of natural forms and enjoyable. But he did not do drawings *for* sculpture as this he felt either weakened the desire to do the sculpture or made the sculpture a dead realisation of the drawing. Two of the drawings in the Ashmolean illustrate these points clearly. *Two Standing Figures*, presented by Kenneth Clark, who had been Keeper of Fine Art in the Ashmolean from 1932 to 1934, is among Moore's most 'finished' drawings (PLATE 22).It is an end in itself, deriving directly from sketch-book studies of 1939, with the qualities of a painting. Its visceral and structural character were, with details such as the cleft head of the figure on the left, ideas which Moore would continue to develop, but these two figures never became three-dimensional.

The other drawing, presented by the Contemporary Art Society in 1948 only four years after it was drawn, is a sheet of studies from a sketch-book (PLATE 21). The sheet encompasses all of Moore's preferred figurative compositions, the sitting, standing and reclining figure. At the top left are three internal/external reclining forms from the 1930s, which, chrysalis-like, evolve across the sheet into forms suggestive of some of the best

known of Moore's sculpture in the coming decade. Equally interesting are the pencil inscriptions which provide us with a number of insights into Moore's thinking:

> The human body is sculptural/ but that is all the more reason [erased] for it to be a subject for/sculpture, it means that the sculptor cannot be a copyist,/ but must make changes and recreate it [erased] /[But erased] The human body is what we know most about, because/ its ourselves; and so it moves us most strongly [x] we can make complete / identity with it./ We kick out from the past two [4] or three [5] painters, one or two sculptors/ It is the integrity dynamic which counts, as though his intention was so/ tremendously important to him that it comes through [scored out] shining through without being anywhere near achieved.

Whereas in the 1920s Moore had worked directly into the stone without preparatory models, in the late 30s he began a process, reinforced during the war by necessity, that developed into a practice, of working out ideas from sketch-book drawings in hand-sized sketch models or maquettes. Two of these were bequeathed to the Ashmolean by Cicely, Lady Hendy, widow of Sir Philip Hendy, who as a young man at Christ Church in 1919 had shared rooms with another benefactor to the museum, R.A.P. 'Bobby' Bevan, son of the Camden Town artist Robert Bevan. The Hendys became close friends of the Moores, after Hendy shared the bad press that attended the exhibition of the work of Moore, Graham Sutherland, and John

FIG. 23 Henry Moore, *Projects for relief sculptures on London University*, 1938. Pen and ink, chalk and wash; 374 × 276. Signed and dated and inscribed with title. Art Gallery of Ontario, Toronto

Piper, that he organised at Temple Newsam near Leeds in 1941. Hendy was described by the correspondent of the *Harrogate Advertiser* as a 'mental art quack', but 55,000 people made their way to see the exhibition at Temple Newsam, a not very easily accessible country house, particularly in wartime.

Woman Reading (PLATE 23) has been dated to 1946, but may be earlier. Its antecedent appears to be the never-completed project for a series of reliefs on Senate House, University of London, which Moore had begun to think about at the request of the architect Charles Holden. A design from 1938, once owned by the Hendys, shows a series of six female figures reading, and foreshadows Moore's post-war return to figuration (FIG. 23). The little figure in

terracotta, probably fired in the Moores' kitchen stove, is unique. It was never editioned in bronze perhaps because it appears to fail a number of Moore's own exacting criteria. It has the appearance of being unfinished, having a rough-and-ready facture which is not characteristic of Moore's work even at maquette stage. It is unusually specific as to detail, the face being highly expressive, and the hair clearly described. The clothes, in particular the jacket or cardigan, are as near-contemporary as anything in Moore's work, where apparel is usually reduced to a biblical simplicity. The mien of the piece is charmingly ordinary, having little of the universality which was the sculptor's aim in each finished piece. More fundamental however, is the work's failure to resolve itself in terms of composition. From certain angles the centre does not hold, tension between the parts is missing, and the suspicion is that had the piece been scaled up it would not have achieved the necessary *gravitas*. Perhaps it is a portrait of Cicely Hendy herself, made one companionable wartime evening, fired overnight in the cooling heat of the kitchen stove, and given as a present, before the sculptor's exacting personal censorship thought better of it. This would make it doubly unique. It has all the immediacy of that desirable quality derived from being *a mano*.

Fragment Figure (PLATE 24) by contrast, is, despite its title and truncated form, a deeply considered piece, and with its applied *verdigris* patina, highly finished. It was cast in an edition of ten. It is related to a number of full-scale figures such as the Time-Life *Reclining Figure* of 1952, and is Moore's most literal classical

PLATE 23 Henry Moore, *Woman Reading*, 1946

expression. Moore had been to Greece for the first time in 1951, and said of this visit that it strengthened his intention to use drapery in his sculpture, a desire ignited by the *Shelter Drawings* made in the London Underground, in which he saw eternal forms in the figures of sleeping Londoners sheltering during the Blitz in 1941. Two sources have been accepted for this small piece. One, Michelangelo's *Aurora* from the Medici Tombs in San Lorenzo, Florence, which Moore had first seen when on a travelling scholarship in Italy in 1925, the other the fifth-century BC *Ilissos* (FIG. 3). Its truncated character and intimations of flight are in sympathy with the concerns of the next generation of sculptors, translated into a classical idiom.

It may not have been fortuitous that of the seven maquettes owned by the Hendys, these were the two chosen for the Ashmolean (the other five went to the Henry Moore Centre, Leeds), for they create happy associations with works that have long been in the collections. In particular *Fragment Figure* resonates with another small bronze reclining figure, also truncated, attributed variously to Guglielmo della Porta and Benvenuto Cellini (FIG. 24) and with the red wax *bozzetto* of *Aurora* after Michelangelo (FIG. 25), both given by Chambers Hall in 1855.

It is significant that in the years after the war, when a younger generation was finding a new language to express the human predicament, Moore, by now the grand old man of British sculpture, felt confident enough to revert to the classical sources he had so fiercely rejected as a young man. There is a parallel

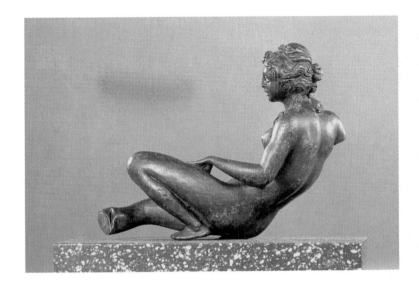

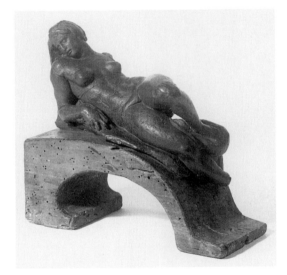

above: FIG. 24. Perhaps by Benvenuto Cellini (1500–71), *Reclining Nude*. Bronze. Presented by Chambers Hall, 1855.

left: FIG. 25 After Michelangelo, *Aurora*. Red wax. Presented by Chambers Hall, 1855

here with the classicism espoused by Picasso and others, among them Ossip Zadkine, immediately after the First World War. Zadkine, who was half Scottish but who originated from Smolensk, was sent for training

PLATE 24 Henry Moore, *Fragment Figure*, 1957

65

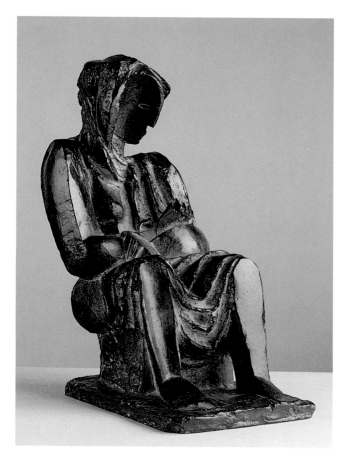
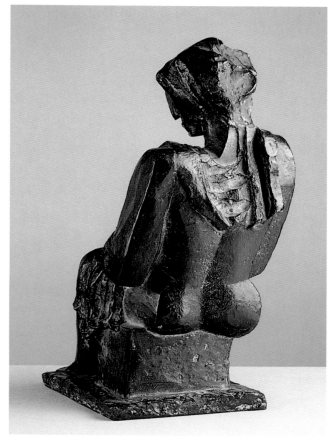

PLATE 25a and b
Ossip Zadkine,
Seated Woman,
1937

in business management to Sunderland in 1906, exactly contemporaneously with Gaudier-Brzeska in Bristol. In Sunderland Zadkine attended the local Art School, and the following year went to London to the Regent Street Polytechnic and the Central School of Arts and Crafts. He was befriended by the painter David Bomberg, and visited the British Museum to see the Elgin Marbles and discover the ethnographic collections from Africa and Polynesia. Zadkine settled in Paris in 1909 and

by 1913 he was exhibiting there with Duchamp-Villon and Laurens. His work was included in the Post-Impressionist and Futurist exhibitions at the Doré Gallery in London that year, and in the Allied Artists Association in 1914. Examples of his direct carving in these exhibitions won him Gaudier-Brzeska's respect. With Jacques Lipchitz and Alexander Archipenko, Zadkine was the most effective applier of Cubist principles into three dimensions. By way of a classicism derived from Cubist principles,

evident in *Seated Woman* (PLATE 25), he went on to develop a figurative expressionism. In 1950 he won the International Prize for Sculpture at the Venice Biennale. His best known work came late, in the form of a commission for the *Memorial to the Destruction of Rotterdam* (1953–4).

The Ashmolean piece was exhibited at Zadkine's first post-war exhibition in London, at the Leicester Galleries in 1952. It was a subject he was to return to after the war. The figure's incised face recalls the draughtsmanship of early Greek pots and the cursive line of Jean Cocteau, while the back recalls the masculine torso and pelvis of the *Belvedere Torso.*

In the post-war years, when the country gradually began to take pride in Moore's international success, there was a tendency to magnify his status at the expense of his contemporaries. In the 1920s, however, Moore was one among a number of others exploring a new language of form and expression. One of these, who at the time was both a mentor and a friend to Moore, was Leon Underwood, an energetic, polymathic and charismatic artist and teacher.

If Moore was single-minded in his interests and wholly concerned with the nature and making of sculpture, Underwood was not. Indeed his versatility probably hindered his reputation, and weakened his voice. Underwood was a utopian, pantheist and mystic whose responsive nature meant his own style was extremely fluid and open to new influences. He was himself eclectic, and his facility allowed him to move from painting to sculpture, drawing to printmaking with ease, never concentrating with the necessary single-mindedness on any one of them. His creativity did not stop at art, but encompassed poetry, novel writing and theorising on art. It may have been Underwood that Moore had in mind when he said that it was a mistake for a sculptor or painter to speak or write about his work, because it released tension needed for that work (*Birmingham Post*, 12 August 1966).

Underwood had little formal education, and his training, first at the Regent Street Polytechnic and subsequently at the Royal College of Art before the outbreak of the First World War, had consisted largely of copying from casts after the antique. At the end of the war he attended Professor Tonks's class at the Slade, which was regarded as the best and most liberal environment of the day. It was Tonks who encouraged Underwood to set up the Brook Green School of Art in 1921. As the prospectus declared, the aim was to break away from 'the harmful and repressive influences of orthodox art training' (quoted in Neve, p.45). Teaching revolved round life-drawing (PLATE 26 and FIGS. 22a, b, c), and was quite unlike that conducted in the established art schools. Underwood broke away from the traditional day-long poses which had reduced life-drawing to an academic exercise, and encouraged his models and pupils to work at speed in an attempt to capture form, volume and movement, an early drawing is inscribed "25 mins" (FIG. 22a). In 1924 R.H. Wilenski, a champion of the Modern Movement, commented that Underwood used drawing 'as a method of research ... [he] simply experiments

PLATE 26 Leon Underwood, *Study of a Female Nude*, 1920s. Conté crayon; 420 × 259. Signed. Presented by Garth Underwood, 1996.371

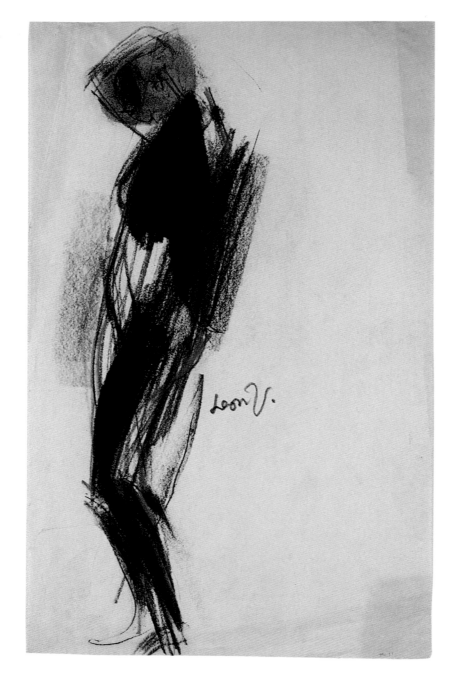

in abstract combinations of plastic forms and rhythm' (quoted in Rutherston 1924). Among the young artists in London who were excited by Underwood's charismatic personality and innovative approach were Moore, Blair Hughes-Stanton and Rodney Thomas. The latter two artists were studying at the Byam Shaw School, where W.S. Hartrick, who had known Gauguin and Van Gogh, was not allowed even to talk about French art, and where pupils spent their first year with a 6H pencil drawing plaster casts. Among Underwood's full time pupils who had not been able to get into established schools were Eileen Agar and Gertrude Hermes, both of whom went on to make sculpture. Agar became a leading British Surrealist and Hermes, in her wood engravings, the foremost exponent of Expressionism in this country. For another of the school's achievements was the successful experimentation with wood engraving which contributed to its renaissance in the 1920s and 30s (FIG. 26).

In 1925, after the Underwood School outings to the Paris Exposition des Arts Decoratifs and Yugoslavia, Underwood went to northern Spain to see the recently discovered cave paintings of Altamira. This provided him with a theory of the cycle of styles which was to preoccupy him for the rest of his life, and which took him on a three-year journey to Mexico, via New York. This expedition was paid for by Eileen Agar. On his return he founded the magazine *The Island*, also funded by Agar, which in four issues in 1931, 'offered a joint resistance to commercialised art' (quoted in Neve, p.134), and championed the belief that poetic imagination was more important than style or

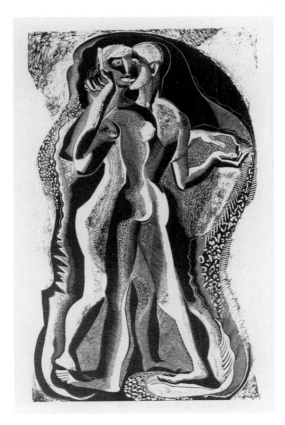

FIG. 26 Gertrude Hermes (1901–83), *Two People* 1934. Wood engraving; image 520 × 310. Signed, dated and numbered: 20/30. Purchased, 1995.108

method. Contributors included Ralph Chubb, John Gould-Fletcher, Hermes, Hughes-Stanton, C.R.W. Nevinson, and Henry Moore. Underwood's output continued unabated after the war, stimulated by a visit to West Africa in 1945. He executed a number of public commissions including murals and stained glass for the church of St Michael and All Angels, New Marston, Oxford in 1955. The sinuous curves in the trumpeting angels on the wall above the main altar owe something to his pupil Blair Hughes-Stanton, but they were considered indecorous by the congregation, and

the mural was instantly hidden behind a curtain. Now, however, it is fully displayed.

In 1985 Underwood's son Garth presented a definitive group of wood engravings by his father to the Ashmolean. These came to the Museum not because of the richness of its sculpture collections but rather because of the importance of its wood engravings. Ten years later Garth Underwood presented an important group of drawings which demonstrate the innovatory nature of his father's technique, a painting, the sensitive portrait *Charles Ashdown* of 1922 (FIG. 28) and three bronzes, each with an integral base designed and made by the sculptor himself.

The earliest of the bronzes, *Elijah's Meat* (PLATE 27) is an entirely satisfactory three-dimensional piece. Dated to 1938, in an edition of seven, its approach to the whole problem of the relationship of the inside to the outside, which was also exercising Moore and Hepworth at the time, is resolved in a linear manner. There may be a personal significance to this particular subject for, referring to the difficult times of making ends meet while pursuing an unfashionable vision, Underwood later said 'The ravens fed me' (quoted in Neve, p.214). *Elijah's Meat* takes an honourable place within the collections beside the sixteenth-century gold-patina *Adam*, from the Fortnum

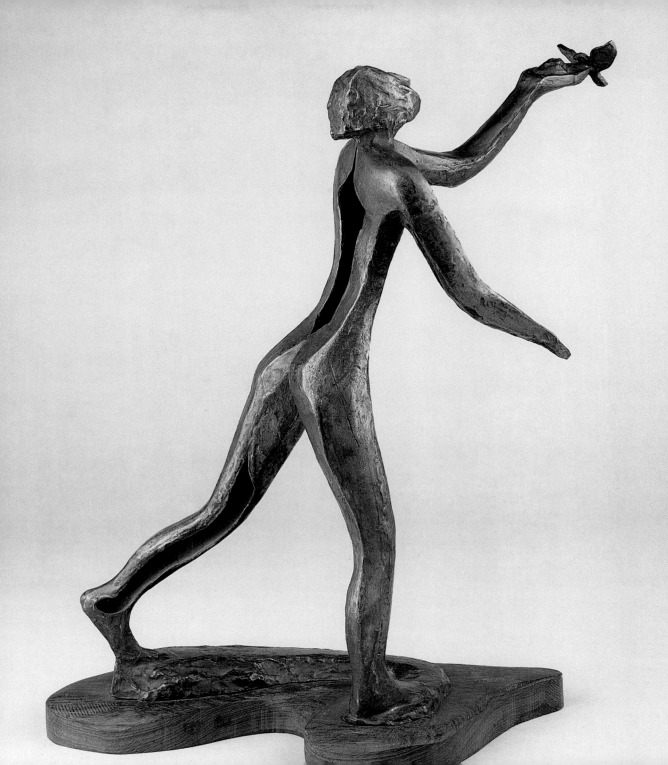

Collection (FIG. 27): both stride forward, and both appear intent on hearing or seeing something beyond sight.

The other two bronzes are later works, and were cast by Underwood using the kitchen saucepans. The *Samson and Delilah* of 1960 (PLATE 28), recalls classical compositions such as *Pan and Syrinx* and *Angelica and the Hermit*, but is devoid of the lasciviousness associated with these, presenting a more tender and vulnerable expression of the biblical story. The stringy contour lines of drapery, most visible in the robes on Delilah's back – achieved literally with string in the wax model – are a period detail, and derive from Underwood's drawing technique. Style apart, this is,

however, a traditional piece. A more difficult work in every way is *Moses Transcendent* of 1961 (PLATE 29). At first glance it is difficult to read: its literal, narrative quality is at odds with the medium, the cloud that swirls about the figure of Moses, defies nature in a baroque sort of way (see FIG. 29). Its complexity of composition makes it practically impossible to photograph satisfactorily, for it has no front, no back, no profile. Only God handing down the tablets has a true perspective. As it spirals upward it appears in stasis, an endless motion trapped in the sculpture. This energy combined with its facture as a 'home-made' (the use of string is very evident here) contributes an elemental African quality, which would have been instantly recognisable to radicals in search of the 'primitive' at the beginning of the century.

Underwood is indeed difficult to categorise, intensely prolific in any number of directions, and a seed-bed of ideas. He was immensely influential as a teacher, having a string of disciples. If there is an enduring theme in his work, it is the human figure, whether on the architectural scale of the vast and never-completed *Cathedral* (1930–32) intended to stand on the South Downs, in the sinuous parabolas of drawing, wood engraving, or lithograph, or the small bronze table pieces. A further link between media and technique is evident in the balletic movements contained in much of Underwood's sculpture, which make them in some ways drawings in space. His work remains outside the mainstream, a boiling pot of eclecticism: Surrealism, archaic, primitive and classical by turns. In the work of Ossip Zadkine, there is, however, a European parallel

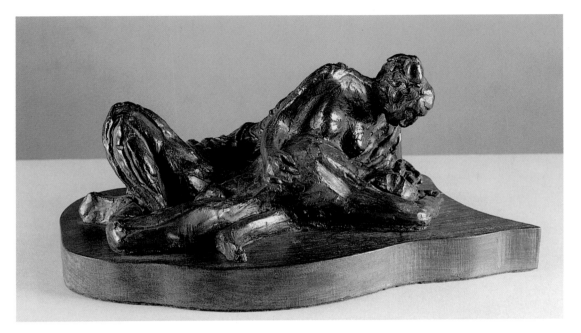

PLATE 28 Leon
Underwood,
*Samson and
Delilah*, 1960

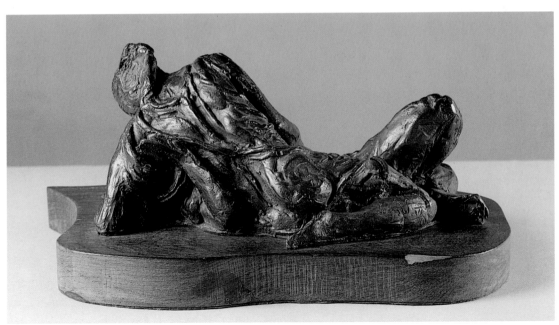

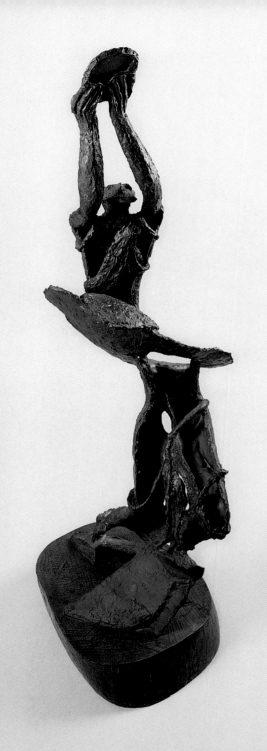
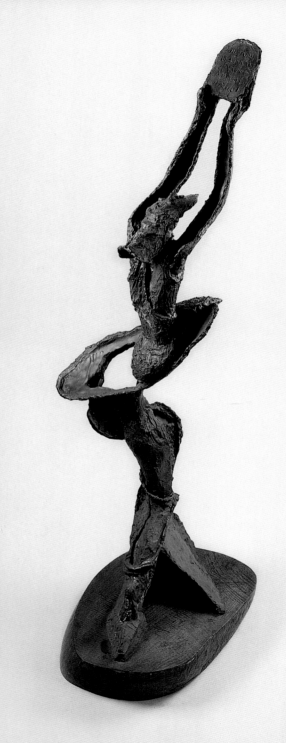

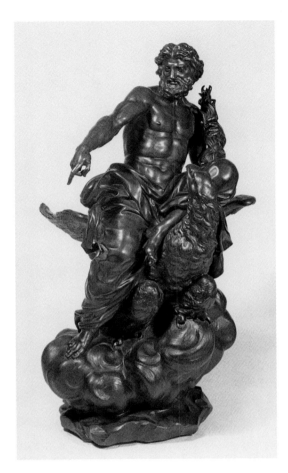

FIG. 29
G. Piamontini
(1664–1742),
Jupiter. Bronze.
Presented by Mrs.
J.C. Conway, 1959.

scarification on individual pieces. Even some subjects, particularly musical instruments and biblical sources, are common to both.

Portraits

The development of photography did not, as was widely feared in the later nineteenth century, spell the death of art, but it did call into serious question the need for portraits as record. This came at a time when political and economic ideologies were developing which challenged the notion of the individual: the etymology of Communism and democracy, the currency of phrases such as 'universal suffrage', 'the people' and 'the majority'; and the hard facts of World War, genocide and mass murder. Other trends, less extreme, such as mass education, mass employment and unemployment, even mass leisure and popular culture, have contributed to an artistic expression that in the hands of some of the greatest artists of the century – Matisse, Picasso, Epstein, Moore – becomes a search for and celebration of the universal.

Portraiture has been the 'bread and butter' of artists working to commission across the ages. Satisfaction was not always to be guaranteed on either side, as witness Gainsborough's lament in the eighteenth century about the frustrations of 'Face-painting'. Economic dependency, the time for the necessary sittings, the need to pander to another's vanity, dissatisfaction at the outcome on the part of the sitter, relations and friends; though reactions are rarely as extreme as Clementine Churchill's to Graham Sutherland's

to Underwood. It is a coincidence that both Zadkine and Underwood were attending the Regent Street Polytechnic together in 1907, but there are more than coincidences in the work of their middle and late years, which they discussed at the Antwerp Biennale in 1959 (Neve, p.152). Both are concerned to produce effects of movement in space, which in each case leads to an upward thrusting composition of arms, heads and hands; both use devices such as bound drapery and sgraffito marks or

PLATE 29a, b Leon Underwood, *Moses Transcendent*, 1961

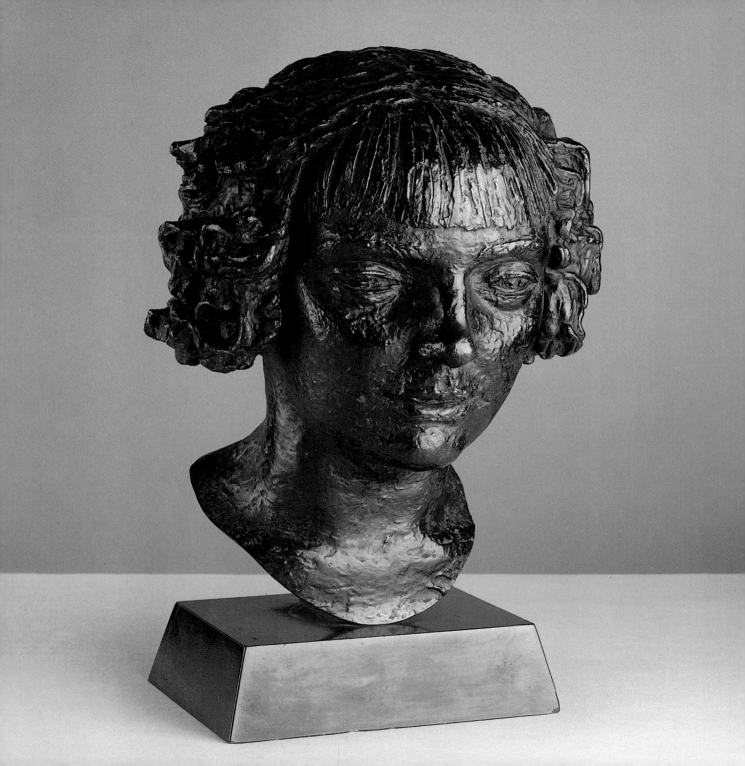

portrait of her husband, Sir Winston Churchill. No wonder the most satisfying portraits in the twentieth century are, by and large, personal and private, the artist or sculptor concentrating on themselves, and on family and friends prepared to pose.

Heads became subject to subjectivity. We might feel that while the least important thing about them is the likeness, nevertheless some of the most dynamic images of the century are heads, from Gaudier-Brzeska's *Hieratic Head of Ezra Pound* (1914, private collection, USA) and Frank Dobson's *Sir Osbert Sitwell Bt.* (1923, Tate Gallery) to Eduardo Paolozzi's *Richard Rogers* (1988, National Portrait Gallery, London) and Marc Quinn's *Self-Portrait*, cast in his own blood (1993, Saatchi Collection, London).

Jacob Epstein excelled at portraiture and it dominated his output. This is one of the contradictions of his long and controversial career. Whereas his direct carving minimised detail and emphasised an elemental universality, his portraits, all modelled in clay and cast in bronze, are highly particularised. The sitter is often tied to time and place by fashion, whether of hair, clothes or jewellery. This is a new departure, in marked contrast to the portrait-style inspired by Rodin, which had stripped sitters of their temporal assets and presented society women as though nude (FIG. 30). Between the wars, like Chantrey a hundred years earlier, Epstein recorded an epoch, and – another contradiction – became a highly sought-after portrait sculptor, whose sitters' list reads like *Who was Who*. This incidentally may have contributed to Epstein's fall from grace in

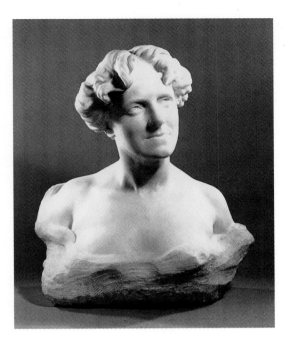

FIG. 30 Francis Derwent Wood, *Mrs Otto Gutekunst*, 1915

the eyes of the modernists. As his facility made him successful, so it undermined his critical reputation, exactly as happened to his friend Augustus John. It was the artistic equivalent of what the politician Ramsay Macdonald described as falling into the aristocratic embrace. Epstein's style and technique, however, particularly in the manner of adding the clay in a way that did not deny it as the original medium, was deeply influential and much imitated.

Noneen (Head of a Girl) is an early example of Epstein's established portrait style: the emphasis on modelling, the tool marks left raw, the pupils deeply incised though not yet gouged out (PLATE 30). Executed in 1919 and exhibited the following year, the rubbed-down nose speaks of youth, the fashionable bob of

PLATE 30 Jacob Epstein, *Noneen*, 1919

77

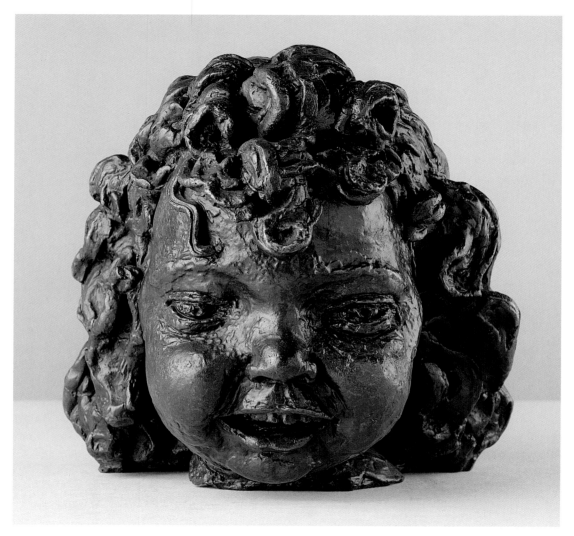

emancipation. We know nothing of Noneen, yet we do know what she will look like in middle age, and clearly it is a very good likeness. The *Ninth Portrait of Peggy-Jean (laughing at 2 years 9 months)* is another (PLATE 31). Peggy-Jean is the sculptor's eldest child and, as the title suggests, the subject of a series of portraits,

'Laughing' and 'Sleeping' studies that have an exactitude and a familiarity which, for most people, is found in the family snap. Children are notoriously difficult to present in painting and sculpture; unquiet sittings and a tendency to winsomeness militate against a successful likeness, as does the lack of character to latch

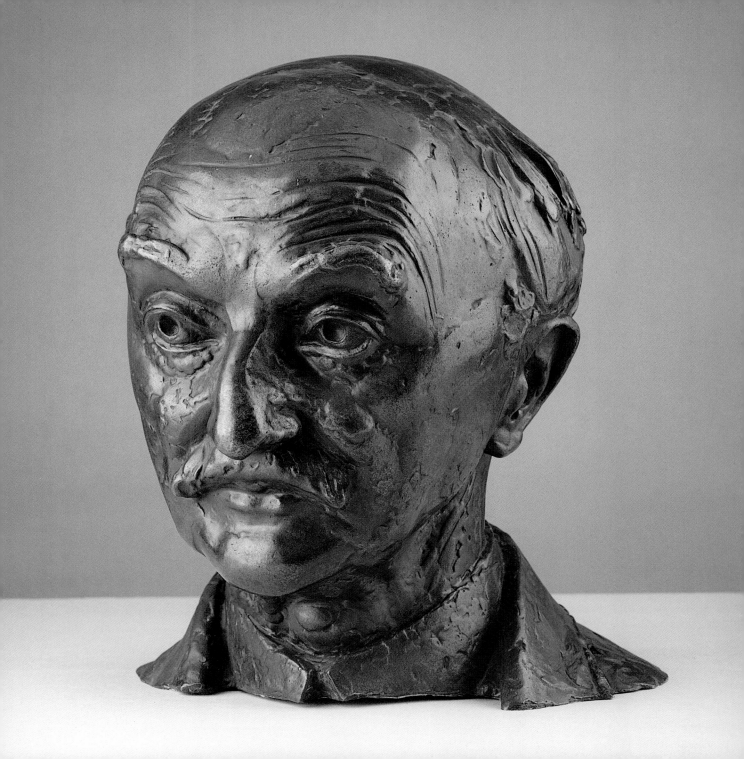

FIG. 31 Eric
Kennington, *A
Soldier in the 16th
Canadian Scottish
Regiment*, 1919.
Black chalk
heightened with
white on green
paper; 554 × 441.
Signed and dated.
Presented by the
Contemporary Art
Society, 1963.114

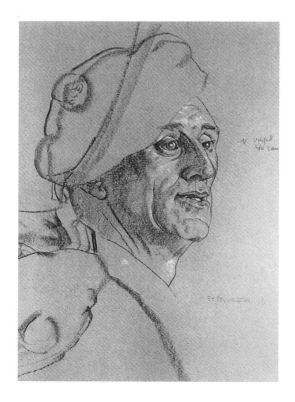

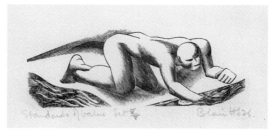

FIG. 32 Blair
Hughes-Stanton
(1902–81),
Standards of Value
from *Seven Pillars
of Wisdom*, 1926.
Wood engraving on
Japanese paper; 133
× 203. Signed,
dated, and
numbered: *Set 5/5*
corrected to *Set 8/8*.
Purchased,
1995.232.4

Four other portraits in the collection exemplify two aspects of the portrait: the known and the unknown or anonymous. Of the known, *Thomas Hardy* (PLATE 32) by Eric Kennington is a fragment from the seated figure commissioned by subscription for Hardy's native town of Dorchester in Dorset in 1931. The novelist and poet, who had died in 1928 and been buried in Westminster Abbey, is here presented as an ordinary cove, the son of an artisan, a character from one of his own novels. Epstein, who had hoped to be given the commission, described Hardy as represented by Kennington 'as a dejected market gardener, with a trilby hat, seated as he might appear on a Sunday morning, deploring a bad crop of spinach' (Epstein, p.72). Eric Kennington had made his name depicting the ordinary soldier (FIG. 31), alongside whom he had served throughout the 1914–18 war, on memorials, notably the *Memorial to the 24th Division*, (1924, Battersea Park). T.E. Lawrence sat on the Hardy Memorial Committee and Kennington had illustrated Lawrence's *Seven Pillars of Wisdom, A Triumph* (1926). Kennington had also gathered a group of artists to illustrate Lawrence's epic, among them Augustus John, William Roberts, and Edward Wadsworth, and the younger artists Gertrude Hermes and Blair Hughes Stanton. The latter provided a series of eleven wood engravings, which owe something to the simplified forms of Kennington's stone memorial figures (FIG. 32). Kennington later carried out the recumbent effigy for the monument to Lawrence at Wareham in Dorset, completed in 1940. Here, as on the war memorials, the detail is

on to. Here, however, Epstein has captured a recognisable wilful, foot-stamping tendency with paternal affection, and one can just see the red hair and freckles of the wayward child. Epstein said of her that she was 'a real source of inspiration. I never tired of watching her' (Epstein, p.177).

PLATE 33 Ursula Tyrwhitt, *Gwen John*, 1907

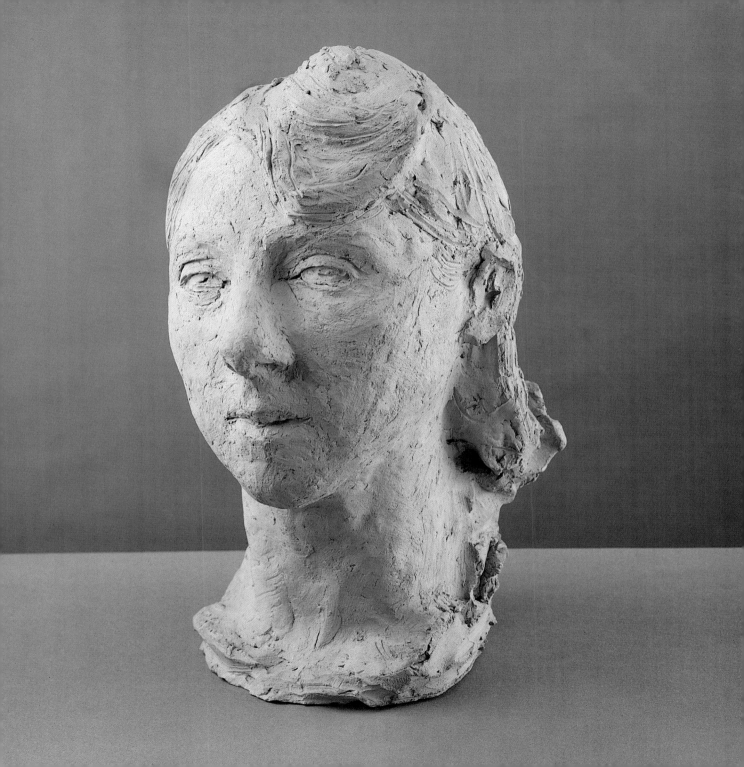

simplified, in this case to a schematic Arab robe. As with Epstein, Kennington's medium and the purpose appear to dictate a difference of approach and technique.

The portrait head of *Gwen John* (1876–1939) is by a painter who as far as we know, made only this one piece of sculpture (PLATE 33). Ursula Tyrwhitt came from, and was married into, a dynasty of Oxford dons, the Tyrwhitts, classicists in the eighteenth century, promoters of art in the nineteenth. She had attended the Slade School of Art in the 1890s, where she met the Johns, brother and sister. In 1907, when she made this portrait, she was at the Atelier Colarossi, while Gwen John was working in

Paris as one of Rodin's models. On seeing it Rodin is reported to have said 'Continuez'. Its raw, almost clumsy, handling gives it a veracity that brings the viewer up close to a shy and elusive personality. It captures a quality that a photograph might project merely as primness, so subtle that it could easily be withdrawn or lost under the prying gaze of the lens.

Two busts in the collection can, through their anonymity, lay claim to something of the universal quality that was an aspiration of so much twentieth-century sculpture. Bertram Mackennal's *Betty* (1925), who remains unknown to us, is a fine example (PLATE 34). The sculptor exhibited other heads, whose names, too, would fit comfortably into a Betjeman poem. The smooth polished surface of *Betty* is in strong contrast to Epstein's *Noneen*, the hieratic, symmetrical presentation being almost classical, but the plaited 'earphones' suggest a descent from Brunhilde and the Norse Sagas, rather than Helen of Troy. Just as the bobbed and shingled heads of Epstein's young women suggest emancipation and an engagement with the contemporary, so Mackennal's young woman – and there are many like her in the work of Gilbert Bayes and others (FIG. 33) – suggests a more recidivist approach to life, a more purist, albeit bohemian, line, less gin and jazz, more Barron and Larcher.

Coloured Girl from Massachusetts (PLATE 35) which was owned by the painter Oravida Pissarro, is rare on a number of counts. It is made from rosewood, and is late in time, for it appears to have been made in 1962. The sculptor Dora Clarke was half American, and

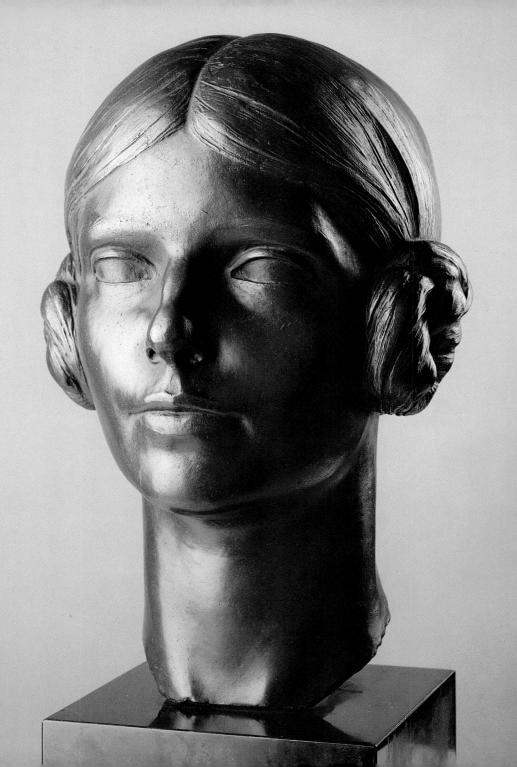

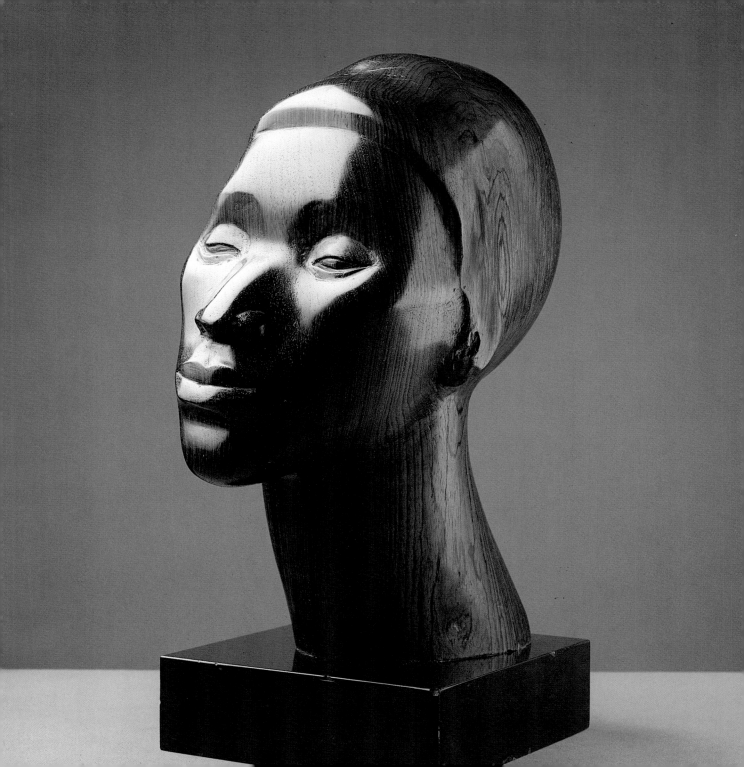

was at the Slade with Stanley Spencer, David Bomberg, Paul Nash, Mark Gertler, William Roberts, and C.R.W. Nevinson. In the 20s she travelled in East Africa recording the tribespeople in sensitive drawings (FIG. 34) and portrait busts, which display an affectionate, unwittingly patronising approach comparable to Karen Blixen's in *Out of Africa*, or Elspeth Huxley's in her novels, letters and diaries. The Ashmolean bust has a timeless quality, its pared-down simplicity, accentuated by the medium, has its roots in the ethnographic collections that so excited artists at the beginning of the century. It is truly anonymous.

The self-portrait has become a mode of expression in which artists have been able to argue from the particular to the general. One sculptor whose work has centred almost exclusively on self-representation is Antony Gormley. Sculpture cast from his own body, drawings in his own blood and semen (so that even the medium is self-referential), create images that are essentially unparticularised and universal in their meaning. From this profoundly subjective, solipsistic source, Gormley requires the consideration of much broader values that encompass humanity. His education took him from archaeology and anthropology at Cambridge via three years in India, to the Central School of Art, Goldsmiths' College and the Slade. In 1981 he completed *Bed*, made from 'Mother's Pride' white sliced bread, in which he had eaten out the imprints of his own body. This was shown at the Whitechapel Art Gallery, and provoked a similar outcry to that which had greeted the early work of Epstein and Moore. Epstein's

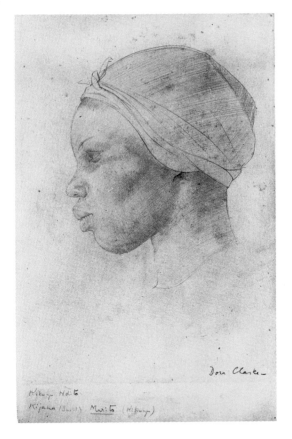

FIG. 34 Dora Clarke, *Head of a young woman*. Pencil; 352 × 217. Signed and inscribed: *Kikuyu Ndito/ Kijana (Swahili) Marito (Kikukyu)*. 1999.60

work has been an acknowledged source of inspiration, overtly in the carved work, and, less obviously, in the modelled and cast work. 'Epstein took the flak for artists' is an observation of Gormley's that the present writer remembers from a television programme in the late 1980s. *Field* (1991), in which thousands of terracotta figures formed an installation the making of which was a collaborative effort, calls to mind Dalou's never completed project entitled *Labour*, of a hundred years earlier, coincidentally its installation in which the

PLATE 35 Dora Clarke, *Coloured Girl from Massachusetts*, 1962

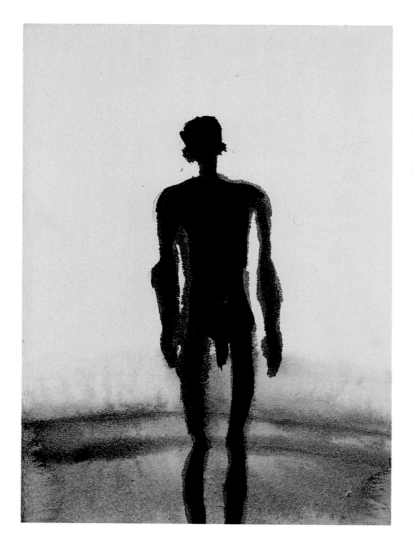

visitor is necessarily being watched by thousands of pairs of eyes, creates an affect parallel to that experienced by Bernard Meadows among the crabs on the shores of the Indian Ocean. The *Angel of the North* (1997, Gateshead), whose subject matter relates to the legend of Icarus and echoes the concerns of post-war sculpture, has become a landmark and entered the national visual bank in much the same way as did *Nelson* by E.H. Baily in Trafalgar Square. In 1994 the Museum purchased two drawings of the previous year from Gormley's dealer, Jay Jopling, at White Cube, *Learning to be* and *Lock* (PLATES 36 and

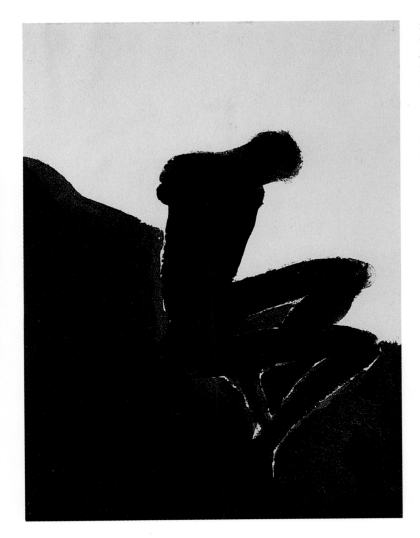

PLATE 37 Antony Gormley, born 1950, *Lock*, 1993. Chinese ink and brush; 191 × 142. Signed, dated and inscribed with title. Purchased with funds from Mr and Mrs Raphael Bernstein, 1994.68

37). The latter is a variation on the *Theseus*, from the Parthenon (British Museum) and echoes Moore's wartime drawings of coal-miners at work. Both drawings are in silhouette: in *Lock* the form is described by the thin, white line of exposed paper, while in *Learning to be* the brushwork depicts a vulnerable figure which, without anachronism, might well illustrate Belsen, Serbia, India or Africa.

In the nineteenth century the male nude had dominated French and English sculpture. In France the academy drawing tradition had centred on it. Rodin had given it a new

87

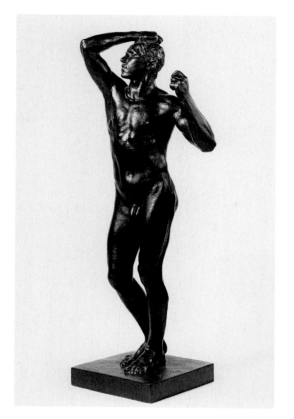

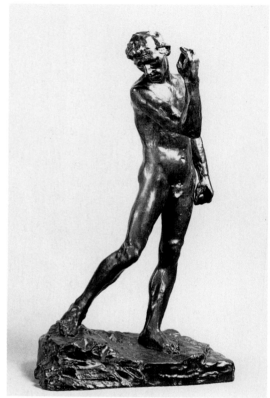

significance in *The Age of Bronze* begun in 1875 (FIG. 35), and he frequently modelled figures in the nude, as in *Balzac* and *Pierre de Wiessante* (FIG. 36) from *The Burghers of Calais*, which he subsequently clothed. In England it was a favourite subject for the modellers of the New Sculpture, which may account for its rarity in the twentieth century. Epstein used female models for male nude subjects, while Moore, who did execute male figures, appears not to have drawn from the male figure for pleasure. An exception to this reaction is Eric Gill, whose *Prospero and Ariel* (FIG. 37) is one of many

studies and designs for the relief sculpture commissioned by the Governors of the BBC for the main door of their new headquarters (1931–3, Broadcasting House, Langham Place). The form, achieved by closely-knit cross-hatching, is more indebted to classical sources than is the resulting carved work, and harks back to pubescent youths in the manner of Reid Dick (FIG. 38).

In reinvesting the male nude with contemporary vigour, as Maillol had done with the female at the beginning of the century, Gormley joins a group of artists whose work in

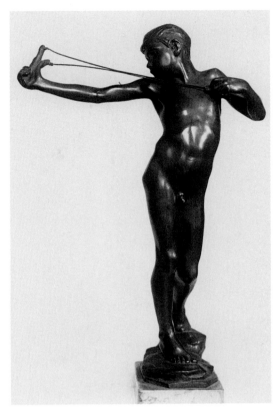

the Ashmolean collections is dedicated to the exploration of humanity, the search for the elusive but evident qualities of the human spirit, no longer tied to the need for record. The camera, far from killing it, freed art, and sculpture in particular, to express feelings and understanding beyond mere visual information, while the narcissism and the semi-divinity of the human form implied in classicism gave way to an awareness of the vulnerability of that naked form and to a change in sensibility. It is the humanity in the work of Epstein, Moore, Underwood and, by implication, in the anthropomorphic work of Meadows and Frink that provides cohesion and continuity in the Century of Extremes. Museums are anthropological store houses, and it is that sense of continuity that public and benefactors most like about the Ashmolean.

SUMMARY CATALOGUE

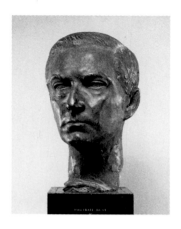

WÄINÖ AALTONEN 1894–1966
Gerald Abraham 1937
Bronze; H.348. Signed and dated.
Given by the sitter, 1947.250. NBP 347

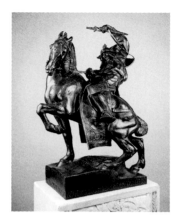

GILBERT WILLIAM BAYES 1872–1953
Sigurd with Gram Sword 1910
Bronze and enamel, marble (1909) on a painted base
(1909–10); overall H.1890. Signed and dated.
Bequeathed by the Revd J. W. R. Brocklebank, 1927.45.
NBP 447
PLATE 8, p.30–31

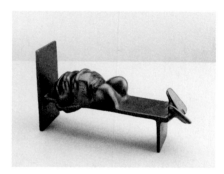

KENNETH ARMITAGE born 1916
The Bed 1965
Bronze; H.118, L.214. Monogrammed, dated and
numbered *2/6*.
Presented by the sisters of Christopher Hewett, 1987.80.
NBP 445
PLATE 16, p.48

DORA CLARKE 1895–1989
Coloured girl from Massachusetts 1962
Rosewood; H.312.
Bequeathed by Orovida Pissarro, 1968.474.4. NBP 460
PLATE 35, p.84

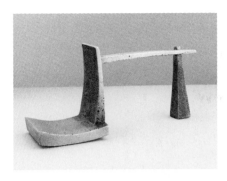

GEOFFREY CLARKE RA born 1924
Angle and Supported Bar 1964
Cast aluminium; 121 × 235 × 75. Monogrammed and
dated and numbered: *6/10* and *4 10.*
Presented by the sisters of Christopher Hewett, 1987.103.
NBP 461
PLATE 18, p.53

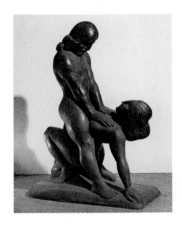

JOHN CLARKE died 1990
Cain and Abel
Bronze; 1092 × 773 × 395. Signed.
OA359. NBP 463

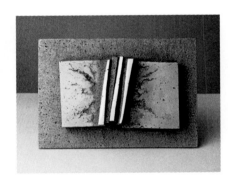

GEOFFREY CLARKE RA born 1924
Books 1981
Cast aluminium; 187 × 269 × 63. Monogrammed and
dated and numbered: *1*
Presented by the sisters of Christopher Hewett, 1987.104.
NBP 462
PLATE 17, p.52

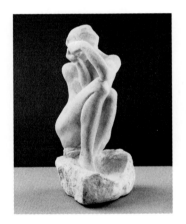

SIR WILLIAM REID DICK RA 1879–1961
Crouching Nude 1916
Chalk; H.232.
Signed and dated and inscribed *Cabaret Rouge/Souchez*
Bequeathed by Major Thomas Bouch, 1963.150.14.
NBP 469
PLATE 6, p.25

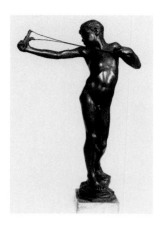

SIR WILLIAM REID DICK RA 1879–1961
The Catapult 1911
Bronze; H.312. Signed.
Bequeathed by the Revd J.W.R. Brocklebank, 1927.46.
NBP 470
FIG. 38, p.89

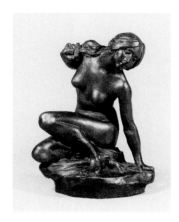

ALFRED DRURY 1856–1944
Crouching Nude 1912
Bronze; H.185. Signed and dated.
Presented by Cyril Andrade, 1956.46. NBP 487
FIG. 12, p.28

JOHN DOUBLEDAY RA born 1947
Maquette for Sir Maurice Bowra 1898–1971, Master of Wadham c.1975
Bronze; H.442. Signed.
Presented by William Gates, 1975.90. NBP 474
FIG. 18, p.49

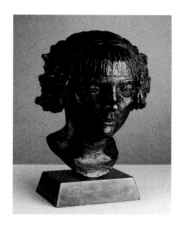

SIR JACOB EPSTEIN 1880–1959
Noneen 1919
Bronze; H.337.
Bequeathed by Thomas Balston, through the National Art Collections Fund 1968.29. NBP 488
PLATE 30, p.76

94

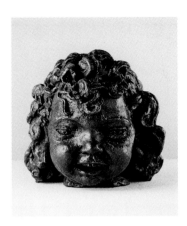

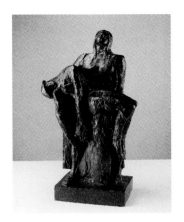

SIR JACOB EPSTEIN 1880–1959
Ninth Portrait of Peggy-Jean 1921
Bronze; H.225.
Bequeathed by Roger Fulford, through the National Art
Collections Fund 1945.70. NBP 489
PLATE 31, p.78

SIR JACOB EPSTEIN 1880–1959
Maquette for the Trades Union Congress Memorial 1955
Bronze; H.545.
Presented by Roderic O'Conor, in memory of his wife,
Lucy Rossetti, 1994.69.
PLATE II, p.38

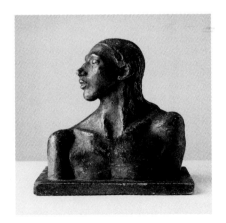

SIR JACOB EPSTEIN 1880–1959
Head of the Dreamer c.1911
Plaster, painted; 149 × 150 × 99.
Presented by Mrs R. M. Bernhard Smith, 1991.435
PLATE 7a, b, p.26–7

DAVID EVANS 1895–1959
*Sir Arthur John Evans, Keeper of the Ashmolean Museum
1884–1908* 1934
Marble; H.665. Signed. HCR 1941.12.33. NBP 490

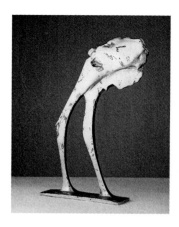

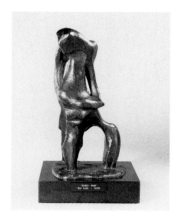

DAME ELISABETH FRINK 1930–1993
*Mirage c.*1969
Aluminium; H.376. Signed and numbered *4/7.*
Presented by Lord McAlpine of West Green, 1969.136.
NBP 495
PLATE 14a, b, p.46

ELI ILAN 1928–82
Ghost Man
Bronze; H.258. Signed and numbered *4/x70.*
Presented by Jacques O'Hana, 1972.56. NBP 352

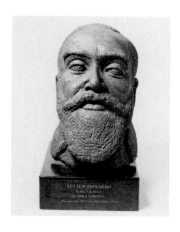

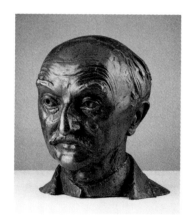

ERIC KENNINGTON RA 1888–1960
Thomas Hardy 1931
Bronze; H.310.
Presented by the artist, *c.*1939. 1944.10. NBP 527
PLATE 32, p.79

DORA GORDINE 1906–99
Lucien Pissarro 1956/7
Bronze; H.317. Signed and numbered *1/4.*
Presented by Orovida Pissarro, daughter of the sitter,
1957.62. NBP 513

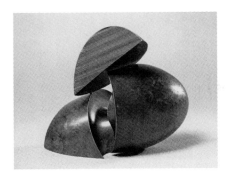

BRYAN KNEALE RA born 1930
Trio 1978
Bronze; H.99. Monogrammed.
Presented by the sisters of Christopher Hewett, 1987.121.
NBP 529
PLATE 20a, b pp.II, 56

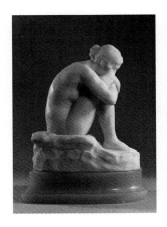

SIR EDGAR MACKENNAL RA 1863–1931
Sappho 1909
Marble; H.223. Signed.
Presented by Mrs C.A. Kraay, the sculptor's daughter,
1952.108. NBP 539
FIG. 10, p.22

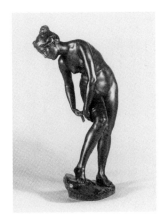

SIR EDGAR MACKENNAL RA 1863–1931
Diana wounded 1905
Bronze; H.369. Signed and dated.
Bequeathed by the Revd J.W.R. Brocklebank, 1927.44.
NBP 538

SIR EDGAR MACKENNAL RA 1863–1931
King George V 1911
Bronze; H.205. Signed.
Presented by Mrs C.A. Kraay, 1982.8.12. NBP 540

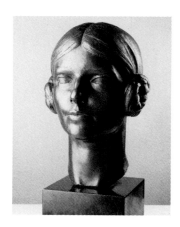

SIR EDGAR MACKENNAL RA 1863–1931
Betty 1925
Bronze; H.318. Signed.
Presented by Mrs C.A. Kraay, 1952.109. NBP 541
PLATE 34, p.83

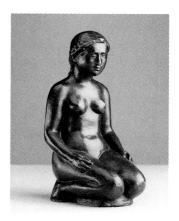

ARISTIDE MAILLOL 1861–1944
Kneeling Nude c.1905
Bronze; H.175. Monogrammed.
Bequeathed by Frank Hindley-Smith, 1940.1.88. NBP 285
PLATE 2a, b, p.18

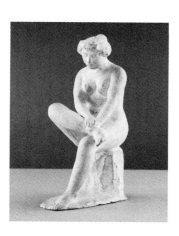

ARISTIDE MAILLOL 1861–1944
Seated Nude c.1902
Terracotta; H.205. Signed.
Bequeathed by Frank Hindley-Smith, 1940.1.87. NBP 286
PLATE I, p.16

BERNARD MEADOWS 1915–1995
Help 1970
Bronze; 144 × 395 × 135. Numbered: *c/6*.
Presented by the sisters of Christopher Hewett, 1987.167.
NBP 543
PLATE 12c, p.41

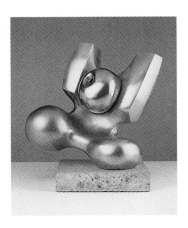

BERNARD MEADOWS 1915–1995
Frightened figure 1976
Bronze; H.292.
Presented by the sisters of Christopher Hewett,
1987.166. NBP 544
PLATE 12a, p.41

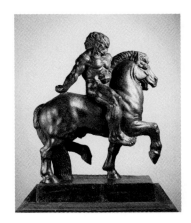

IVAN MEŠTROVIĆ 1883–1962
Marco the king's son on his horse Šarac 1910
Bronze; H.885.
Presented by HRH Prince Paul of Yugoslavia, 1934.297.
NBP 358
PLATE 10, p.37

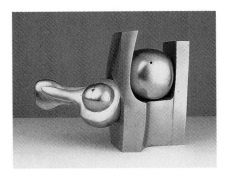

BERNARD MEADOWS 1915–1995
Watchers 1979
Bronze; H.233 × 295 × 149. Numbered: *1/6*
Presented by the sisters of Christopher Hewett,
1987.168. NBP 545
PLATE 12b, p.4

PAUL MONTFORD 1868–1938
Victor Rienaecker 1922
Bronze; H.376. Signed and dated.
Provenance unknown, 1965.65.12. NBP 546

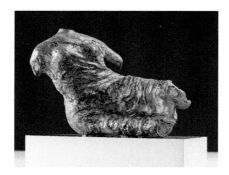

HENRY MOORE 1898–1986
Fragment Figure 1957
Bronze, patinated; 118 × 152 × 102.
Bequeathed by Cicely, Lady Hendy, 1993.330.
PLATE 24, p.64

OSCAR NEMON 1906–85
*Sir Karl Parker c.*1962
Plaster, painted; H.558
Acquired *c.*1962. OA358 NBP 555

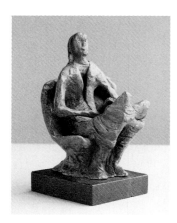

HENRY MOORE 1898–1986
*Woman Reading c.*1946
Terracotta; H.113.
Bequeathed by Cicely, Lady Hendy, 1993.331.
PLATE 23, p.63

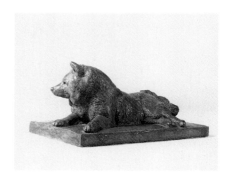

OSCAR NEMON 1906–85
*Topsy c.*1936
Plaster, painted; 204 × 439 × 237
Presented by Miss H.E. Fielder, 1968.15. NBP 556

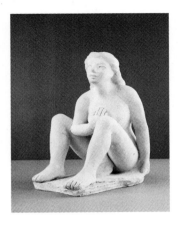

LUCILE PASSAVANT born 1910
Seated Nude
Terracotta; 202 × 172 × 120. Monogrammed.
Presented by the sisters of Christopher Hewett, 1987.171.
NBP 294
PLATE 3, p.19

PHOEBE STABLER died 1955
Faggot gatherer 1910
Bronze; H.225. Signed and dated.
Presented by Cyril Andrade, 1956.45. NBP 570

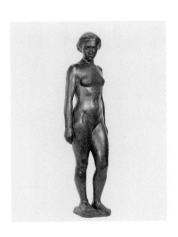

CHARLES SYKES 1875–1950
Eve, a Warning to Woman
Bronze; H.113. Signed.
Presented by Mrs Jessica Sykes, the sculptor's widow,
1953.73. NBP 574

RICHARD SCHIEBE 1879–1964
Standing Nude 1937
Bronze; H.930.
Presented in memory of Mrs Wickham by her daughters,
1967.1. NBP 362

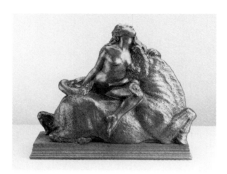

CHARLES SYKES 1875–1950
Europa 1930s
Bronze; 208 × 275.
Presented by Mrs Jessica Sykes, the sculptor's widow,
1953.73.1. NBP 575
PLATE 9a, b, p.34–5

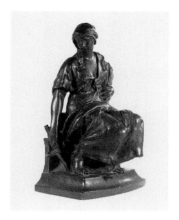

ALFRED TURNER 1874–1940
Peace 1914
Bronze; 305 × 170 × 122.
Presented by Jessica Turner, the sculptor's daughter,
1988, through the National Art Collections Fund,
1988.362. NBP 582
FIG. 9, p.20

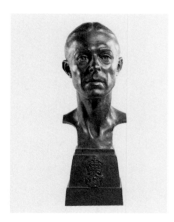

CECIL THOMAS 1885–1976
Archibald G.B. Russell 1926
Bronze; H.582. Signed and dated.
Bequeathed by Archibald G.B. Russell, 1958.57.27.
NBP 577

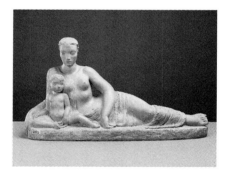

WINIFRED TURNER 1903–83
Reclining Woman and Child 1930s
Terracotta; 300 × 520. Signed.
Presented by Jessica Turner, the sculptor's sister,
through the National Art Collections Fund, 1988.363.
NBP 583
PLATE 4a, b, p.21

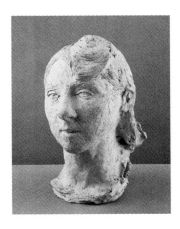

URSULA TYRWHITT 1872–1966
Gwen John c.1907
Terracotta; H.252
Presented by the artist, 1965.44.8. NBP 584
PLATE 33, p.81

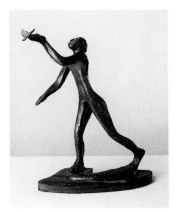

LEON UNDERWOOD 1890–1975
Elijah's Meat 1938
Bronze; approx: 485 × 405 × 175.
Signed *Leon U* twice, dated and numbered *IV/VII*.
Presented by Garth Underwood, the sculptor's son,
1996.380.
PLATE 27, pp.70–71

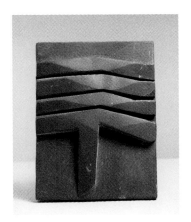

RAOUL UBAC 1910–1985
Ardoise VI
Slate; 175 × 130 × 19. Monogrammed.
Presented by the sisters of Christopher Hewett,
1987.205. NBP 315
PLATE 19, p.55

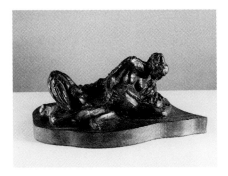

LEON UNDERWOOD 1890–1975
Samson and Delilah 1960
Bronze; 110 × 240 × 180. Signed *Leon U* and
numbered *VI*.
Presented by Garth Underwood, 1996.379.
PLATE 28a, b, p.73

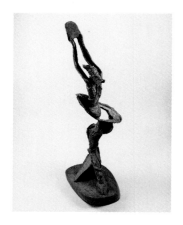

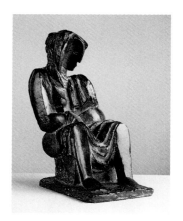

Leon Underwood 1890–1975
Moses Transcendent 1961
Bronze; 1155 × 338 × 465. Signed *Leon U*; Inscribed with
title and dated *61*.
Presented by Garth Underwood, the sculptor's son,
1996.381.
PLATE 29a, b, p.74

Ossip Zadkine 1890–1967
Seated Woman 1937
Bronze; 345 × 200 × 150. Signed and numbered: *2/5*
Bequeathed by Miss Elizabeth Watts, 1989.97. NBP 318
PLATE 25a, b, p.66

Francis Derwent Wood 1871–1926
Mrs Otto Gutekunst 1915
Marble; 600 × 490. Signed and dated.
Presented by Mrs Otto Gutekunst, 1948.192. NBP 595
FIG. 30, p.77

BIBLIOGRAPHY

Books and articles

Beattie, S. *The New Sculpture*, New Haven and London, 1983

Black, P. *Geoffrey Clarke: Symbols of Man, Sculpture and Graphic Work 1949–94*, Ipswich and London, 1994

Bowness, A. *Bernard Meadows, Sculpture and Drawings*, London, 1995

Casson, S. *Some Modern Sculptors*, Oxford, 1928

Cole, R. *Burning to Speak, The Life and Art of Henri Gaudier Brzeska*, Oxford, 1978

Epstein, E. *An Autobiography*, London, 1940

Eustace, K. and Pomery, V. *University of Warwick Collection*, Coventry, 1991

Eustace, K. 'A question of property: A bronze *maquette* by Sir Jacob Epstein', *Apollo*, CXLV, May 1997, pp.60–2

_____ ed. *The Wood Engravings of Gertrude Hermes and Blair Hughes-Stanton*, Oxford, 1995

Irvine, L. and Atterbury, P. *Gilbert Bayes Sculptor 1872–1953*, Shepton Mallet, 1998

James, P. *Henry Moore on Sculpture*, London, 1966

Lecombre, S. *Ossip Zadkine, L'oeuvre sculpté*, Paris, 1994

Neve, C. *Leon Underwood*, London, 1974

Penny, N. *Catalogue of European Sculpture in the Ashmolean Museum 1540 to the Present Day* (3 vols.), Oxford, 1992

Read, H. *A Concise History of Modern Sculpture*, London, 1964 (reprint 1985)

Rutherston, A., ed., *Contemporary British Artists: Draughtsmen*, London, 1924

Silber, E., *The Sculpture of Epstein, with a complete catalogue*, Oxford, 1986

_____ *Gaudier-Brzeska: Life and Art, and catalogue raisonné*, London, 1996

Strachan, W.J. *Open Air Sculpture in Britain, a comprehensive guide*, London, 1984

Whitworth, B. *The Sculpture of Leon Underwood*, Much Hadham and Aldershot, 2000

Exhibition catalogues

Andros, Basil and Elise Goulandris Foundation *Henry Moore in the Light of Greece*, 1996 (Cardinal, R.)

Bretton, Yorkshire Sculpture Park *Kenneth Armitage: 80th Birthday Survey*, 1996

Bristol, Royal West of England Academy: *Bryan Kneale RA RWA: Sculpture and Drawing 1955–1995*, 1995

Cambridge, Kettles Yard *Henri Gaudier Brzeska, sculptor 1891–1915*, 1993 (ed. J.Lewison)

Coventry, Mead Gallery, University of Warwick, *To Build a Cathedral 1945–1962: Coventry Cathedral*, 1987 (ed. Campbell, L.)

Lausanne, Musée des Beaux-Arts *Aristide Maillol*, 1996 (eds. Berger, U. and Zutter, J.)

Leeds, Henry Moore Centre for the Study of Sculpture, *Jacob Epstein: Sculpture and Drawings*, 1987 (eds. Silber, E. and Friedman, T.)

_____ City Art Galleries *Henry Moore: Early carvings 1920–1940*, 1982

_____ *Herbert Read, A British Vision of World Art*, 1993 (eds. Read, B. and Thistlewood, D.)

Liverpool, Tate Gallery *Antony Gormley*, 1993 (ed. Nesbitt, J.)

London, Barbican Art Gallery *Eric Gill: Sculpture*, 1992 (Collins, J.)

London, Daniel Katz Ltd *Renaissance Master Bronzes from the Ashmolean Museum, Oxford, The Fortnum Collection*, 1999 (ed. Warren, J.)

London, Fine Art Society *British Sculpture 1850–1914*, 1968

_____ *Sculpture in Britain between the Wars*, 1986 (eds. Read, B. and Skipwith, P.)

_____ *Geoffrey Clarke, sculpture constructions and works on paper 1949–2000*, 2000

London, Gimpel Fils *Recent Sculpture by Bernard Meadows*, 1959

London, Madden Galleries *Lucile Passavant – Sculptor*, 1965 (Marx, C.R.)

London, Mercury Gallery, *Henri Gaudier-Brzeska, 1891–1915*, 1977 (Cole, R.)

London, National Portrait Gallery *T.E. Lawrence: Lawrence of Arabia*, 1988 (Wilson, J.)

London, Royal Academy *Elisabeth Frink: Sculpture and Drawings 1952–1984*, 1985

_____ *British Art in the 20th Century, The Modern Movement*, 1987 (ed. Compton, S.)

_____ *Henry Moore*, 1988 (ed. Compton, S.)

London, Tate Gallery *The Drawings of Henry Moore*, 1977 (ed. Wilkinson, A.)

London, Victoria and Albert Museum *Ivan Meštrović*, 1915

London, Whitechapel Art Gallery *Gertrude Hermes, bronzes and carvings drawings, wood engravings wood and lino block cuts: 1924–1967*, 1967

_____ *British Sculpture in the Twentieth Century*, 1981 (eds. Nairne, S. and Serota, N.)

New York, Brooklyn Museum *Ivan Meštrović*, 1924 (Brinton, C.)

Oxford, Ashmolean Museum *Alfred and Winifred Turner*, 1988 (Penny, N.)

Saint-Paul, Fondation Maeght *La Sculpture des Peintres*, 1997

Picture acknowledgements

The illustrations in this book are reproduced from photographs taken by the Ashmolean's Photographic Service with the following exceptions:

Fig.11
Reproduced courtesy of Bradford Art Galleries and Museums
Fig.15
Reproduced courtesy of London Transport Museum
Fig.16
Reproduced courtesy of David du R. Aberdeen
Fig.23
Reproduced courtesy of The Art Gallery of Ontario, Toronto

All illustrations have been reproduced in accordance with section 62 of the Copyright Act. Every effort has been made to trace all copyright owners and the author wishes to thank all those who have given permission for inclusion of their works, as listed below. If any copyright owner has been overlooked, and so notifies the Museum, any errors or omissions can then be corrected in future editions.

Frontispiece, Fig.23 and Plates 21, 22, 23, 24
© The Henry Moore Foundation
TUC Memorial, Figs. 11, 15, 16 and Plates 7, 11, 30, 31
Reproduced courtesy of The Tate Gallery, London
Figs. 2, 21 and Plates 1, 2, 19, 25
© DACS, London
Plate 6 and Fig. 38
© Estate of Sir William Reid Dick
Reproduced courtesy of Anne Benton
Plate 8
© The Gilbert Bayes Trust
Plate 10
© The Estate of Ivan Meštrović

Plates 12 and 13
© The Estate of Bernard Meadows
Plates 14 and 15
© The Estate of Elizabeth Frink
Plate 16
Reproduced courtesy of Jonathan Clarke Fine Art
Fig. 18
© John Doubleday
Figs. 19, 20 and Plates 17, 18
© Geoffrey Clarke
Plate 20
© Bryan Kneale
Cover illustration,
Figs. 22, 28 and Plates 26, 27, 28, 29
© Estate of Leon Underwood
Reproduced courtesy of Garth Underwood
Fig. 26
© Estate of Gertrude Hermes
Reproduced courtesy of Judith Russell
Fig. 31 and Plate 32
© Estate of Eric Kennington
Fig. 32
© Estate of Blair Hughes-Stanton
Fig. 33
© The John Downton Trust
Fig. 34 and Plate 35
© Estate of Dora Clarke
Plates 36, 37
© Antony Gormley
Reproduced courtesy of the Artist and Jay Jopling, White Cube Gallery
Fig. 37
© Estate of Eric Gill